film posters of the 90s

the essential movies of the decade

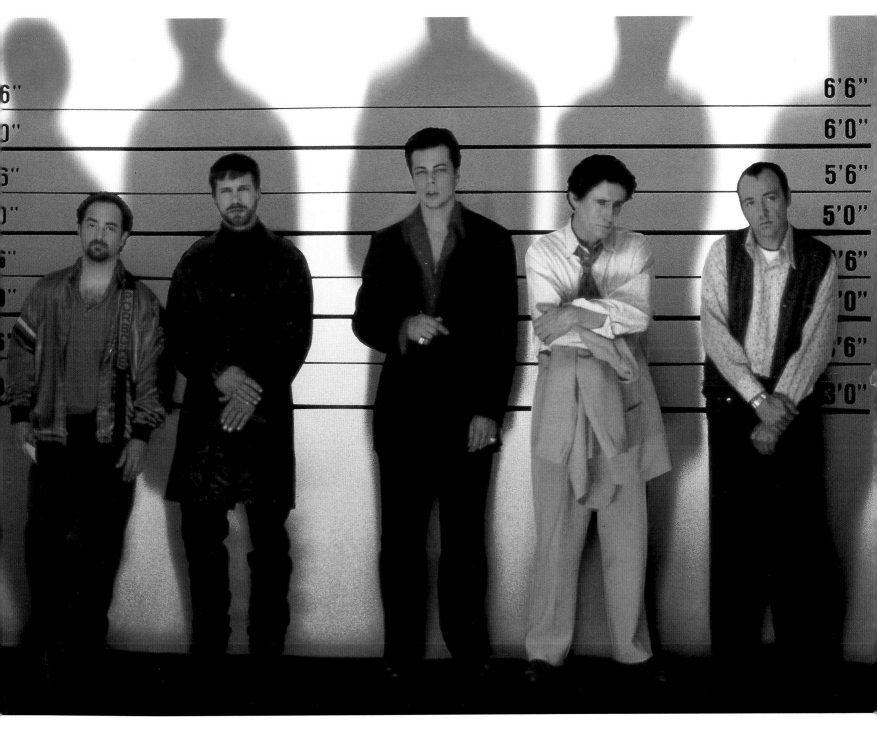

from the reel poster gallery collection

edited by tony nourmand and graham marsh

aurum press

First published in 2005 by
Aurum Press Limited
25 Bedford Avenue
London WC1B 3AT

A catalogue record for this book is available
from the British Library.

ISBN 1 84513 096 0

Art direction and design by Graham Marsh
Page make-up by Trevor Gray
Editorial Assistance by Alison Aitchison and Kim Goddard
Research by Alison Aitchison

Printed in China by SNP Leefung

ACKNOWLEDGEMENTS

Richard & Barbara Allen
Farhad Amirahmadi
Martin Bridgewater
Kamyar Broumand
Joe Burtis
Glynn Callingham
Anne Coco
Tony Crawley
The Crew From The Island
Jack Cunningham
Leslie Gardner
Samuel Hooper
Yoshikazu Inoue
Eric & Prim Jean-Baptise
Andy Johnson
John & Billie Kisch
Peter & Betty Langs
Krzysztof Marcinkiewicz
June Marsh
Kirby McDaniel
Hamid Joseph Nourmand
Gabriella Pantucci
Eric Pelloni
Separate Cinema
Dan Strebin
Sam Wheale

And special thanks to
Bruce Marchant;
without his help, these books would not be possible.

The Reel Poster Gallery
72 Westbourne Grove
London W2 5SH
Tel: +44 (0) 20 7727 4488
Fax: +44 (0) 20 7727 4499
Web Site: www.reelposter.com
Email: info@reelposter.com

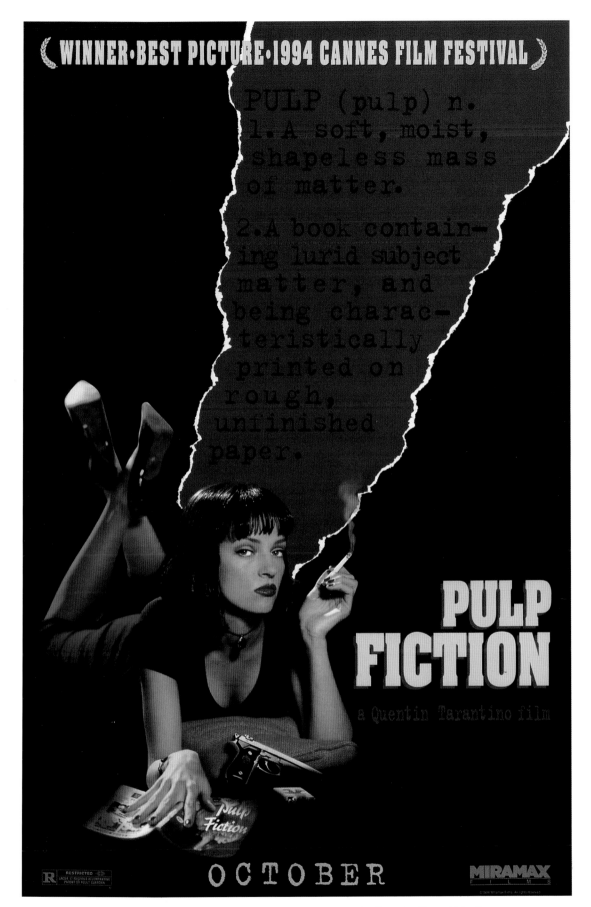

Pulp Fiction (1994) US 41 × 27 in. (104 × 69 cm) (Dictionary Advance) Photo by Firooz Zahedi

contents

4

let's go to work ...

For the film director there is no substitute for the intense rush that making a successful movie delivers. Moreover, if like Quentin Tarantino, all the films you made in the 90s acquire cult status – well, that's 'Le Big Mac'. Tarantino's story is the stuff of legends. He worked in a video store, watched movies until his eyes gave out, absorbed every storyline and camera angle – then went to work. His debut movie, Reservoir Dogs (pages 102, 103), which he also wrote, depicted the aftermath of a bungled heist. It was shot in real-time but it was the high-octane energy of the acting and the hip dialogue that made it stand apart. Michael Madsen's role as the psycho Mr Blonde was so convincing that his big sister Virginia was subsequently able to ward off unwanted advances by simply mentioning who her brother was!

Tarantino owed much of his all-consuming obsession with film to the movies of the French New Wave. It is certainly no bad thing to be influenced by films such as the ultra cool A Bout De Souffle (Breathless) directed by Jean-Luc Goddard in 1959. Even the American poster for Reservoir Dogs (page 103), designed by John Sabel, reflected the monochromatic, pared-down elegance and simplicity of the French New Wave poster art.

As the decade progressed, the new generation of independent film-makers were cutting their teeth on innovative and sometimes controversial movies like The Big Lebowski (page 122). This offering from Joel and Ethan Coen was about kidnapping: however, the brothers were only superficially interested in establishing the logical reconstruction of a crime; their main focus was on developing bizarre characters, crazy situations and sophisticated bluffs. In contrast, Danny Boyle's Trainspotting (page 104), was one of the fastest moving films of the 90s. Set against the soundtrack of Iggy Pop's 'Lust for Life', it explores the lives of a group of youngsters addicted to drugs and living in squalor in Scotland. Although very different, both The Big Lebowski and Trainspotting demonstrated that low-tech and low-budget could translate into big bucks.

The 90s also saw Iranian cinema move into the international arena with critically acclaimed movies like Close-Up and Salam Cinema. The latter, Mohsen Makhmalbaf's award-winning work of 1995, was the unexpected result of an ad in a local Iranian newspaper. Makhmalbaf originally placed the advertisement to help find actors for his new movie and received an overwhelming response. So many people turned up to the auditions that the army had to be brought in to control the crowd. In the end, it was this audition process itself that became the plot of the movie, which was also made to celebrate 100 years of cinema.

In sharp contrast to the independent film-makers, the 90s saw big studios take advantage of the ever-increasing sophistication of hi-tech, computer-generated imagery to create spectacular, mega-budget 'event' movies such as James Cameron's Titanic (pages 16, 17), which cost

$200 million and was awarded eleven Oscars – the first time any film had matched the previously unbeatable 1959 movie Ben Hur. In addition, Steven Spielberg's Jurassic Park (page 77) brought dinosaurs to life with the help of CGI and most impressively managed to maintain a precarious balance between horror film and family entertainment. The Matrix (page 73) was a movie that initially inspired controversy because of its cross-cultural plundering but it set stylistic trends: techno discos, crumbling Victorian houses, abandoned subways – all images now absorbed into fashionable mainstream advertising.

One inevitable consequence of the soaring budgets of such films was the increasing fees paid to the lead actors, which sometimes appeared to exceed the GDP of a small country. Understandably, the studios, having invested heavily, needed to give their latest release the highest possible profile - quite literally in the case of Mission: Impossible (page 109), where Tom Cruise's silhouette dominates the poster design.

While putting together this book, the seventh in the series, it was refreshing to see just how many posters were non-photographic. The poster art for Great Expectations (page 7), Happiness (page 50) and The Pillow Book (page 95) are fine examples of the illustrator's skill used to great effect to produce striking and imaginative images. Likewise, the poster for Your Friends And Neighbors (page 51) was the work of the famous American painter Alex Katz, whose huge canvasses hang in major art galleries throughout the world.

The old adage, 'What goes around, comes around' definitely applies to the art direction and design of many posters produced during the 90s. The Limey (page 121), La Haine (page 32) and My Own Private Idaho (page 19) owe a debt and a tip of the hat to Reid Miles, legendary album cover designer for Blue Note Records during the 1950s and 60s. Even the doyen of movie poster design, the late, great, Saul Bass was assigned to produce a poster for Schindler's List (page 68). Although ultimately produced too late to be used by the studio, it still stacks up against the many other groundbreaking posters such as The Man With The Golden Arm and Vertigo that Bass produced during his lifetime. Interestingly, Bass also had an impact on the poster for Clockers (page 126); clearly based on Bass's 1959 artwork for Anatomy Of A Murder, the poster had to be withdrawn because copyright was not obtained on the image.

Ironically, considering all the mixed media available today, the film poster remains one of the most effective means of promoting movies worldwide. This book reproduces the pick of film posters from the last decade of the twentieth century, guaranteed to evoke movie-going memories, to make you laugh, make you cry, make you want to see the film again – that's a promise.

GRAHAM MARSH AND TONY NOURMAND

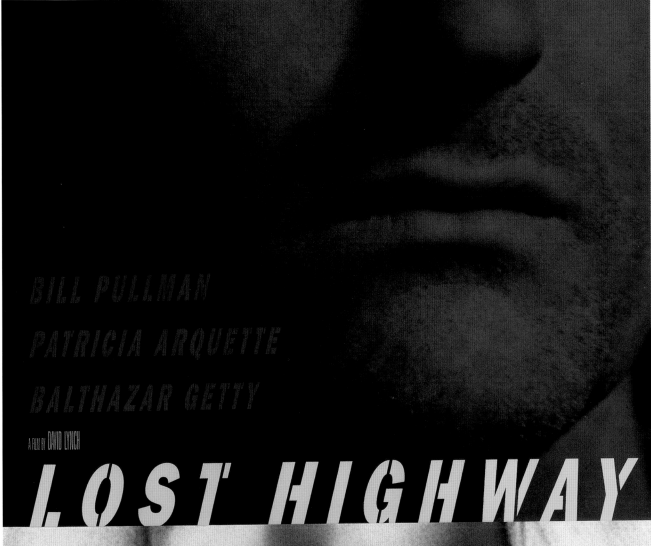

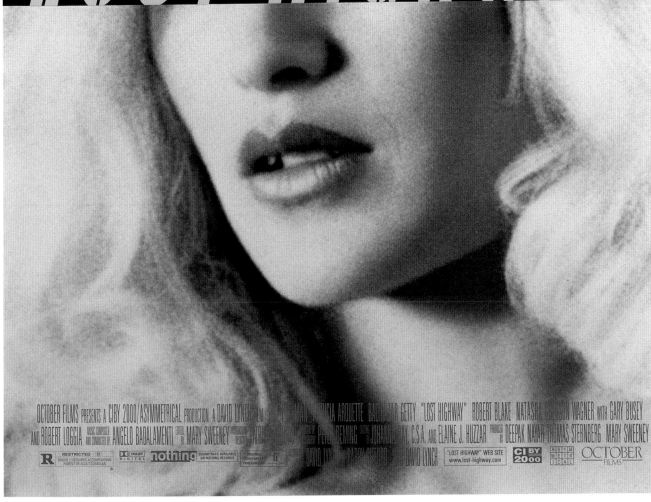

Great Expectations (1998)
US 41 × 27 in. (104 × 69 cm)
(Advance)

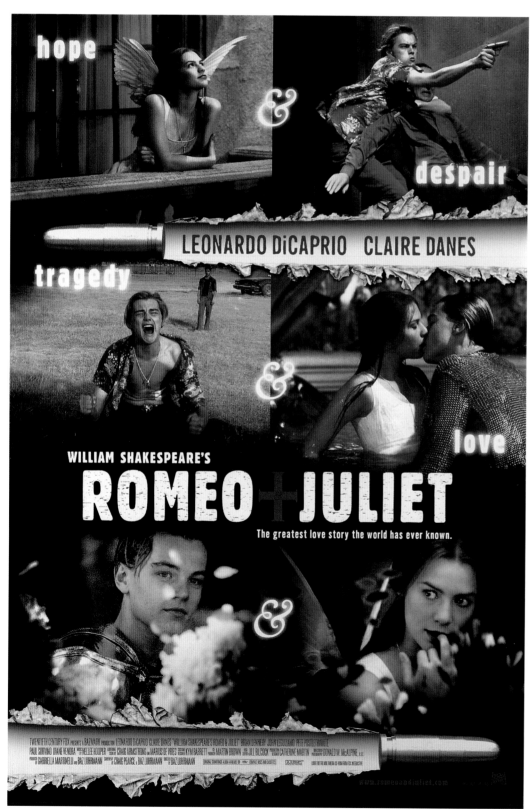

Romeo And Juliet (1996)
US 41 × 27 in. (104 × 69 cm)
(International Style C)
Creative direction by Steve Perani

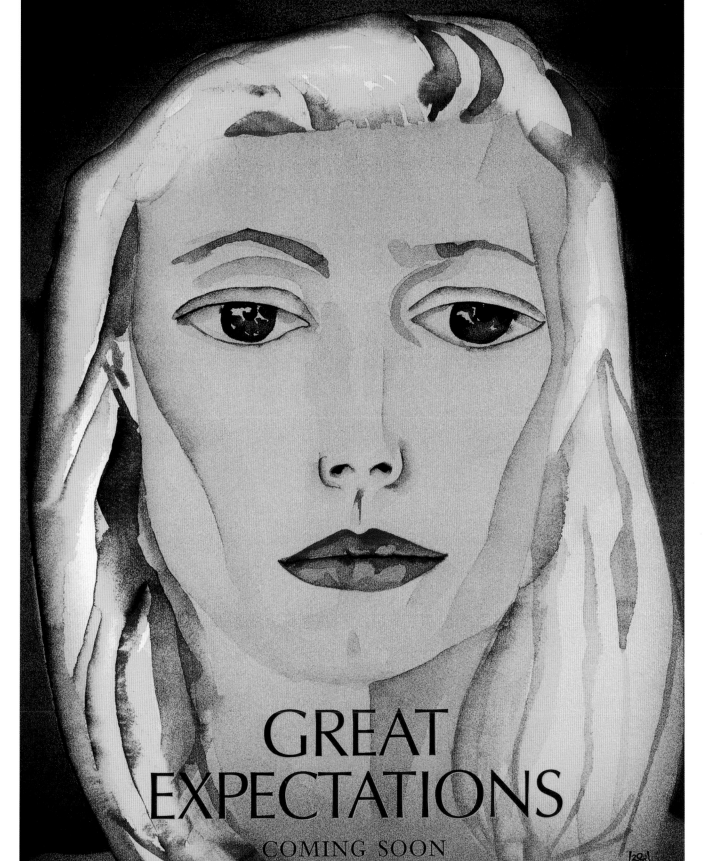

American Beauty (1999)
US 41 × 27 in. (104 × 69 cm)
Creative direction by David Sameth

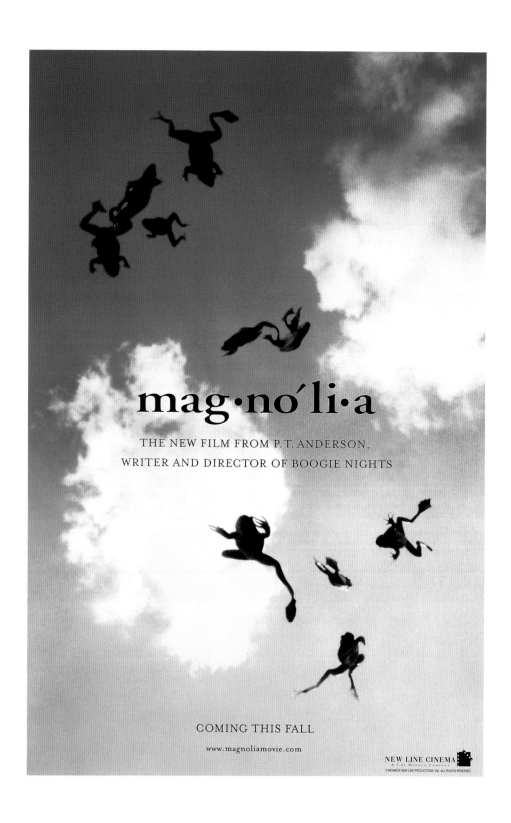

Mag-no'li-a (Magnolia) (1999)
US 41 × 27 in. (104 × 69 cm)
(Advance)
Design by Adam C. Levite & Mark Owens

Ghost (1990)
US 41 × 27 in. (104 × 69 cm)
Photo by Sante D'Orazio
Design by Grace Akazawa

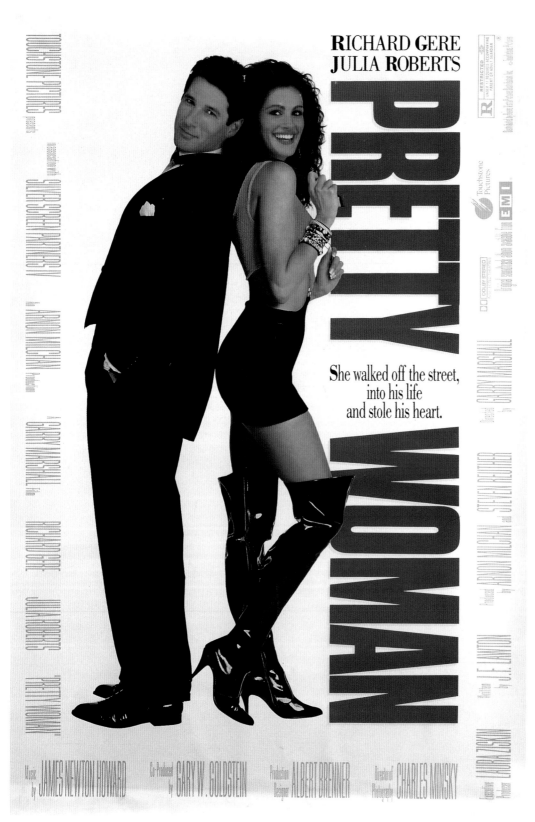

Pretty Woman (1990)
US 41 × 27 in. (104 × 69 cm)
Photo by Herb Ritts & Pete Tangen
Creative direction by Robert Jahn

Parámetros

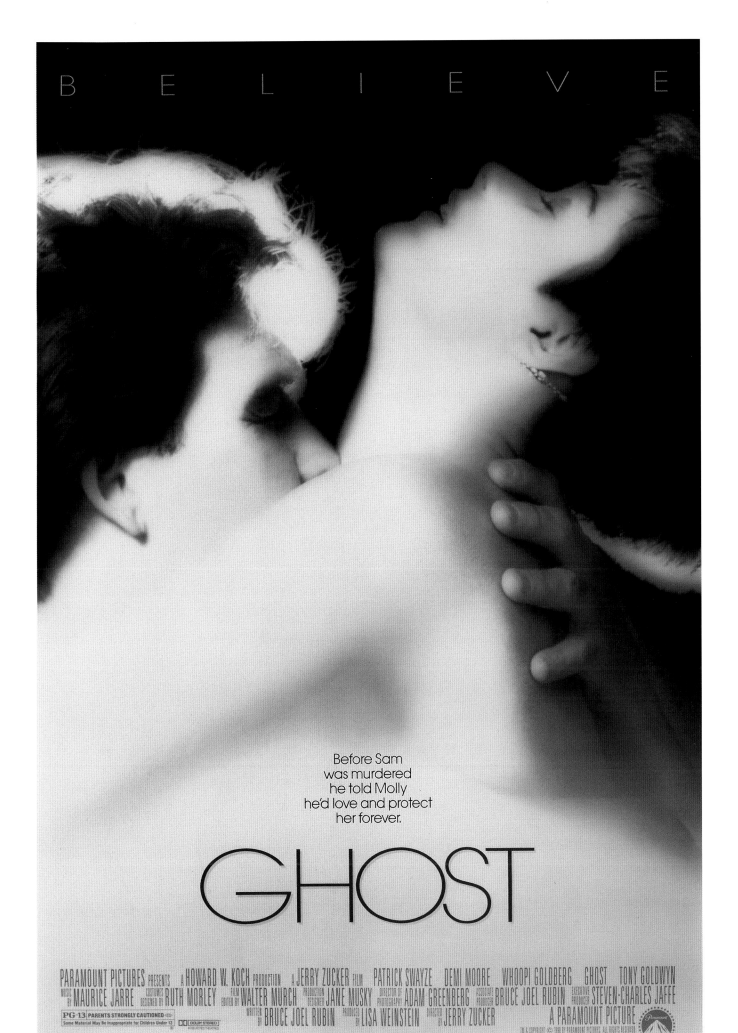

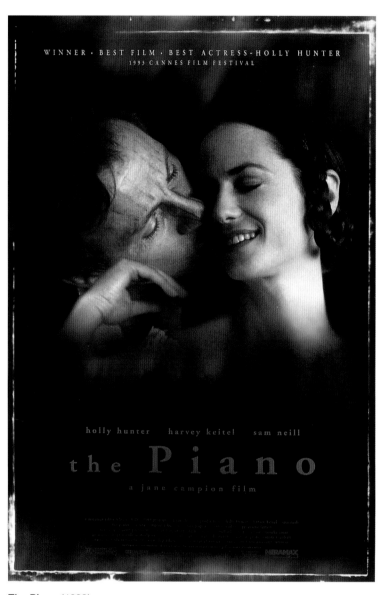

The Piano (1993)
US 41 × 27 in. (104 × 69 cm)
Photo by Deborah Turbeville
Design by Tod Tarhan & Tim Kirkman

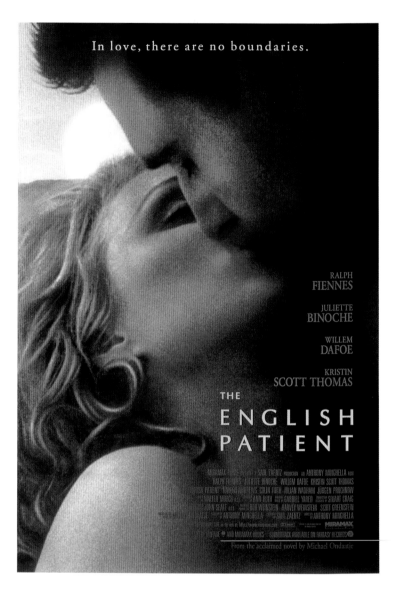

The English Patient (1997)
US 41 × 27 in. (104 × 69 cm)
Design by Giuseppe Ypari & Grace Chang

The Last Of The Mohicans (1992)
US 41 × 27 in. (104 × 69 cm)
Photo by Frank Connor
Design by Olga Kaljakin & Adrienne Graves

Basic Instinct (1992)
US 41 × 27 in. (104 × 69 cm)
Photo by Betina Rheims
Design by Dan Chapman & Kevin Bachman

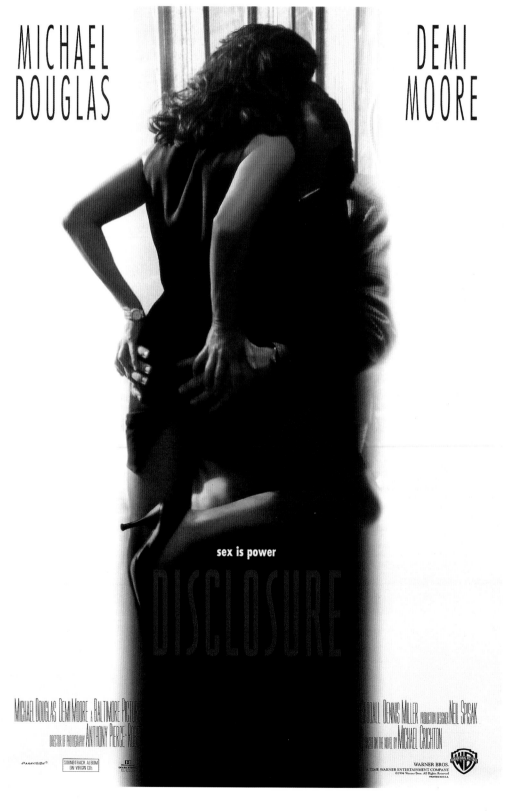

Disclosure (1994)
US 41 × 27 in. (104 × 69 cm)
Art by Myra Wood
Design by Maseeh Rafani & Wendy Furman

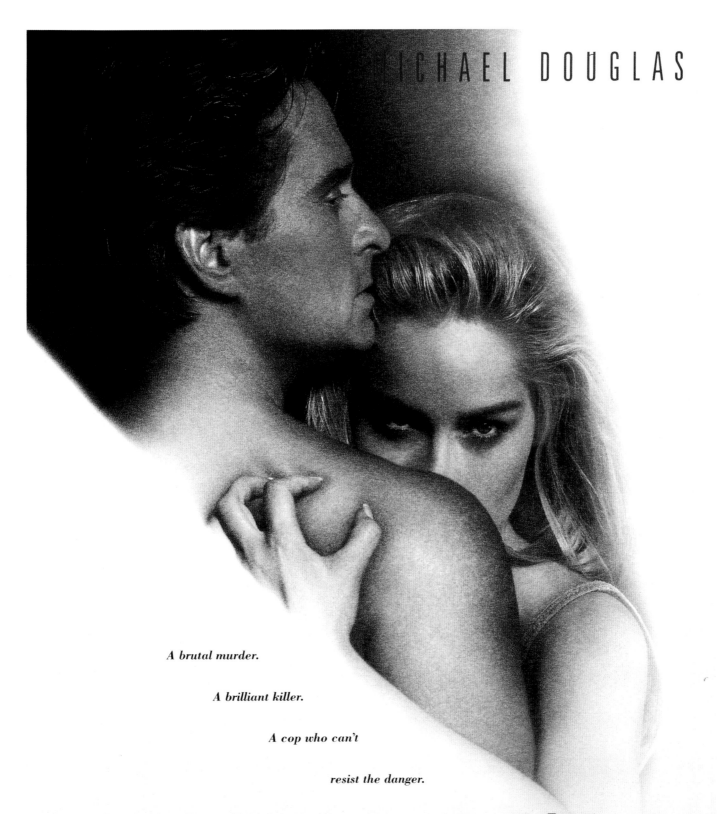

MICHAEL DOUGLAS

A brutal murder.

A brilliant killer.

A cop who can't

resist the danger.

BASIC INSTINCT

MARIO KASSAR PRESENTS A CAROLCO/LE STUDIO CANAL+ PRODUCTION A PAUL VERHOEVEN FILM MICHAEL DOUGLAS BASIC INSTINCT SHARON STONE GEORGE DZUNDZA JEANNE TRIPPLEHORN COSTUMES DESIGNED BY ELLEN MIROJNICK MUSIC BY JERRY GOLDSMITH EDITOR FRANK J. URIOSTE A.C.E. PRODUCTION DESIGNER TERENCE MARSH DIRECTOR OF PHOTOGRAPHY JAN DE BONT A.S.C. EXECUTIVE PRODUCER MARIO KASSAR WRITTEN BY JOE ESZTERHAS PRODUCED BY ALAN MARSHALL DIRECTED BY PAUL VERHOEVEN A TriStar RELEASE

LE STUDIO CANAL+ CAROLCO TRI STAR

PRINTED IN U.S.A.

Titanic (1997)
US 41 × 27 in. (104 × 69 cm)
(Style B)
Photo by Pete Tangen & Marie Wallace
Creative direction by Peter Bemis
Art direction by Jason Lindeman & Rosa Nam

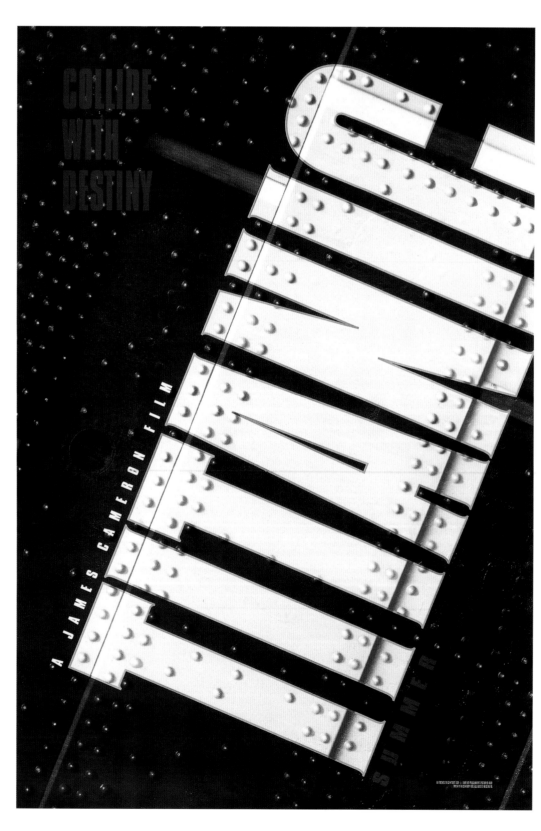

Titanic (1997)
US 41 × 27 in. (104 × 69 cm)
(Advance)
Photo by Mark Silverstein
Art direction by Rick Lynch & Jeff Kerns

18

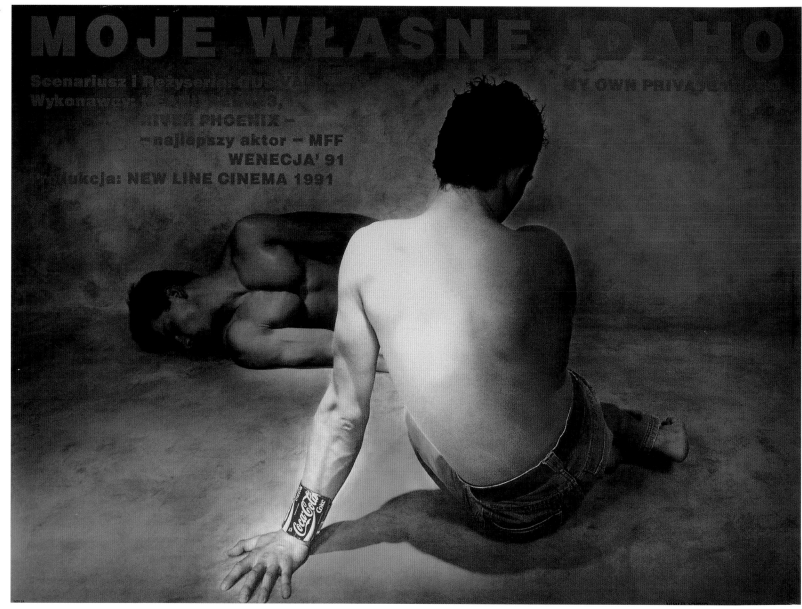

My Own Private Idaho / Moje Wlasne Idaho (1991)
Polish 27 × 36 in. (69 × 91 cm)
Art by Edmund Lewandowski & M. Mankowski

15**My Own Private Idaho** (1991)
US 41 × 27 in. (104 × 69 cm)
Design by Steve Werndorf & Rigel Morrison

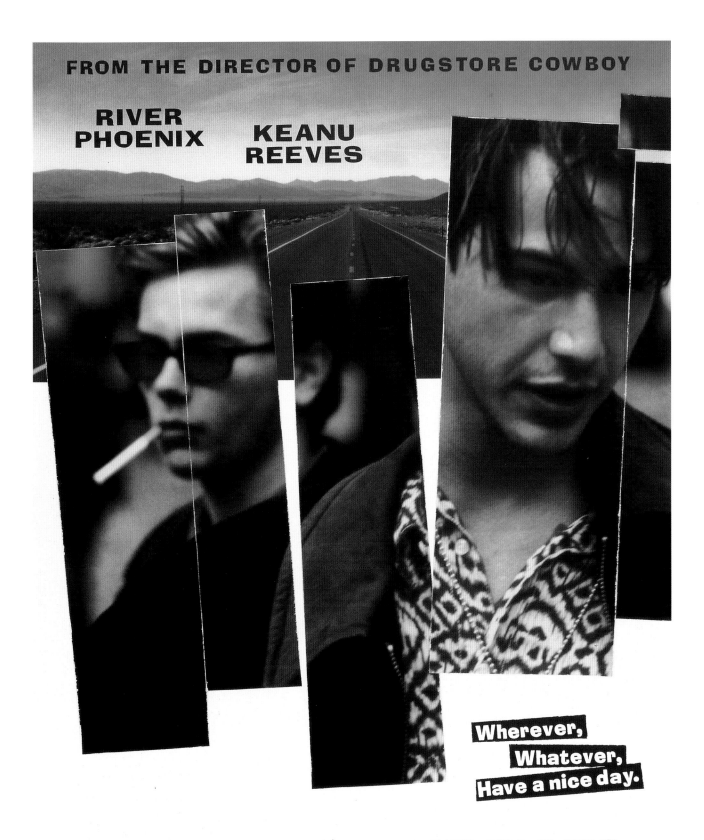

FROM THE DIRECTOR OF DRUGSTORE COWBOY

RIVER
PHOENIX KEANU
REEVES

Wherever,
Whatever,
Have a nice day.

MY OWN PRIVATE IDAHO
A FILM BY GUS VAN SANT

FINE LINE FEATURES PRESENTS RIVER PHOENIX KEANU REEVES IN "MY OWN PRIVATE IDAHO"
JAMES RUSSO WILLIAM RICHERT RODNEY HARVEY MICHAEL PARKER FLEA CHIARA CASELLI AND
UDO KIER AS "HANS" CO-EXECUTIVE PRODUCER ALLAN MINDEL COSTUMES DESIGNED BY BEATRIX ARUNA PASZTOR EXECUTIVE PRODUCER GUS VAN SANT
PRODUCTION DESIGNED BY DAVID BRISBIN EDITED BY CURTISS CLAYTON DIRECTORS OF PHOTOGRAPHY ERIC ALAN EDWARDS AND JOHN CAMPBELL
PRODUCED BY LAURIE PARKER WRITTEN AND DIRECTED BY GUS VAN SANT

FINE LINE FEATURES

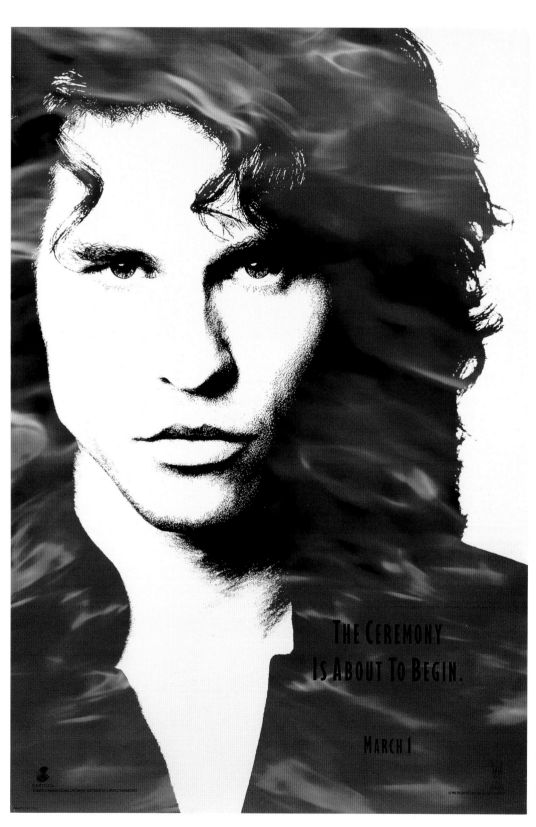

THE CEREMONY
IS ABOUT TO BEGIN.

MARCH 1

JFK (1991)
US 41 × 27 in. (104 × 69 cm)
Design by Christian Struzan

The Doors (1991)
US 41 × 27 in. (104 × 69 cm)
(Advance)
Photo by Sidney Baldwin & Sergio Promoli
Design by Tony Nuss

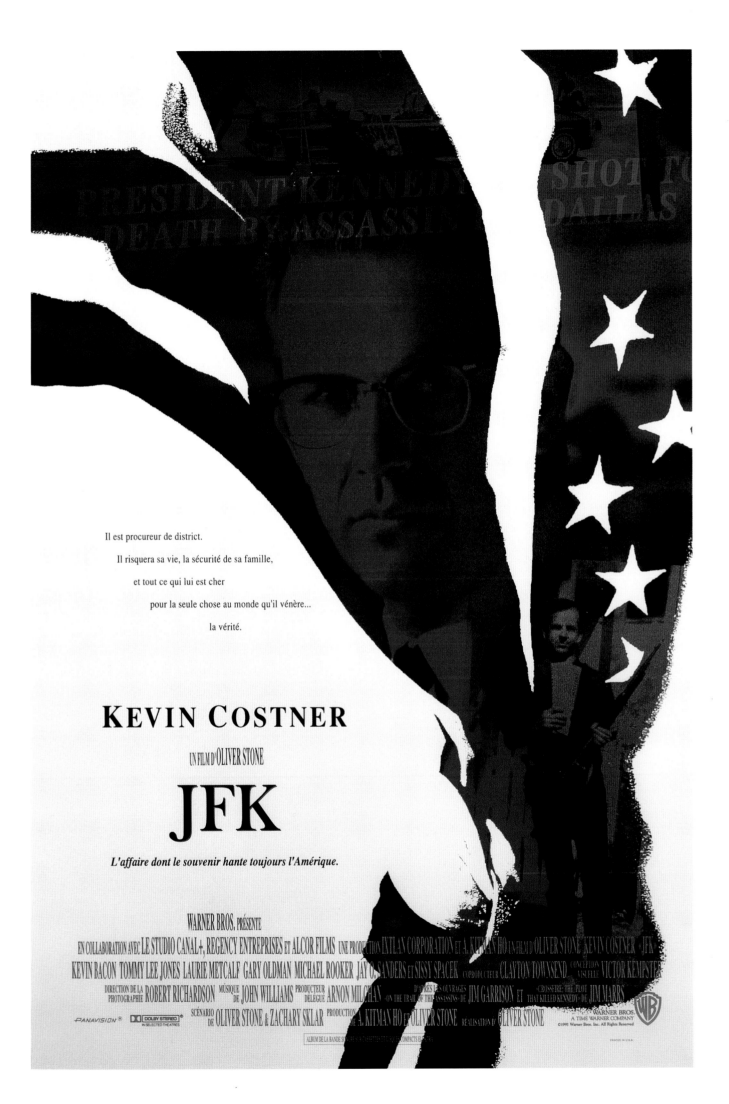

Kafka (1991)
US 41 × 27 in. (104 × 69 cm)
Photo by Jaromic Komarek
Art direction by Tod Tarhan & Stacy Nimmo

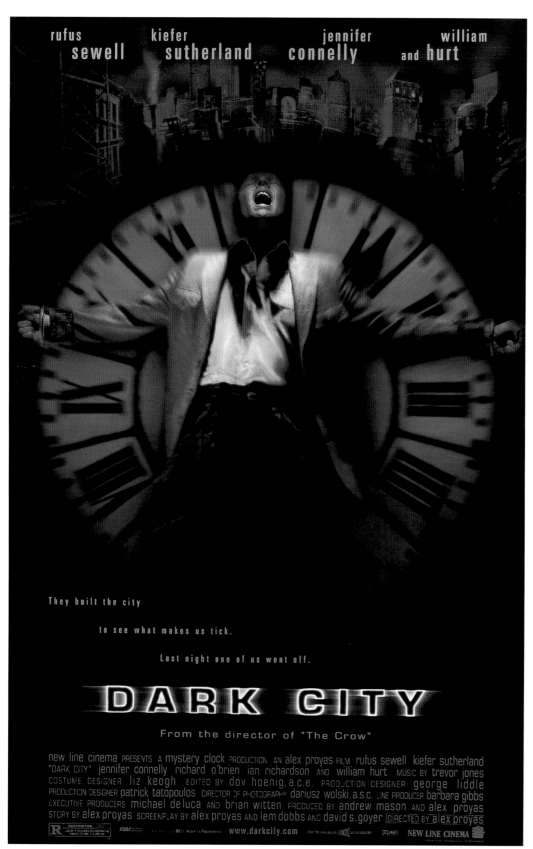

Dark City (1998)
US 41 × 27 in. (104 × 69 cm)
Design by John Peed

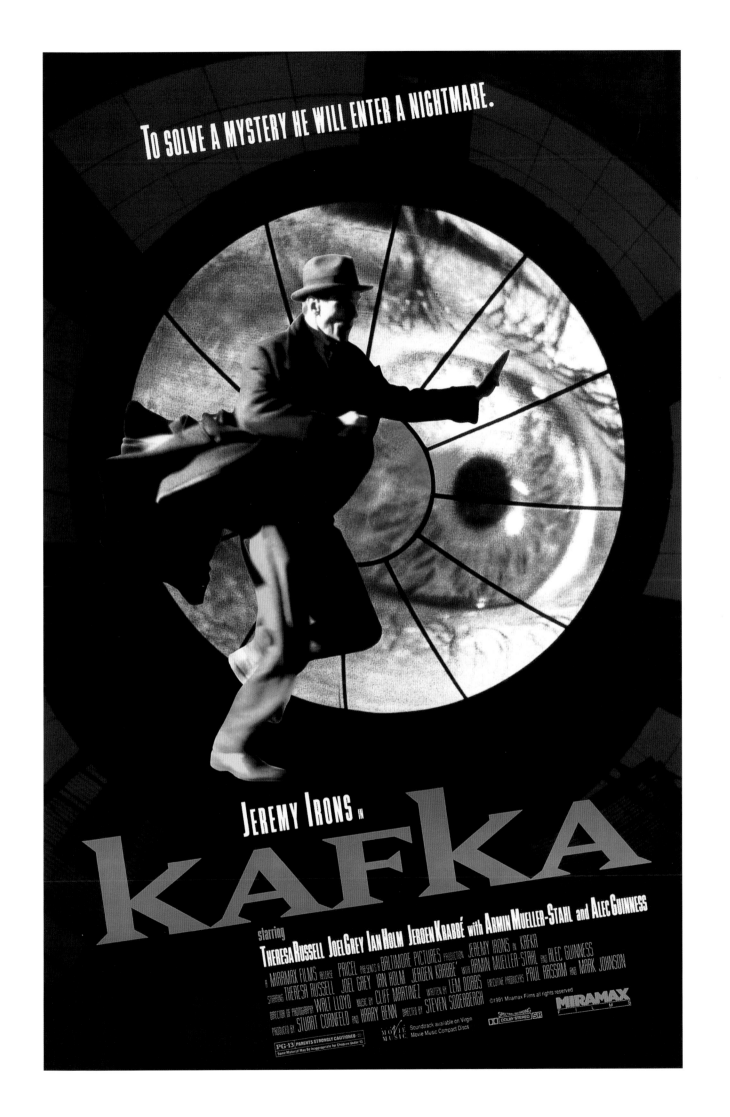

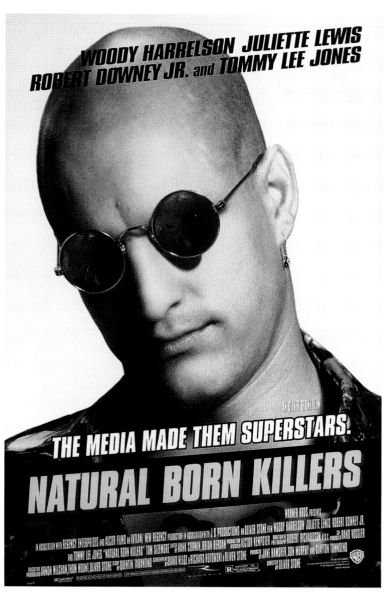

Natural Born Killers (1994)
US 41 × 27 in. (104 × 69 cm)
Photo by Sidney Baldwin

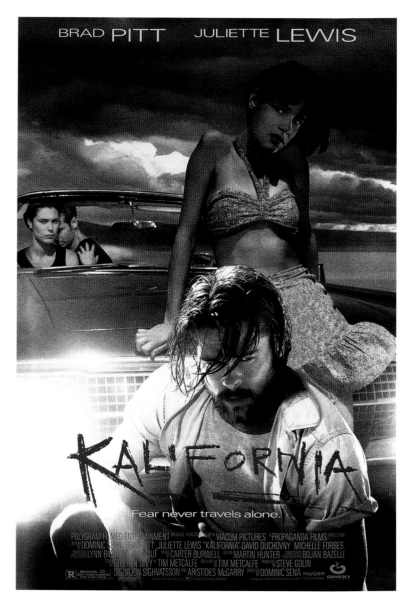

Kalifornia (1993)
US 41 × 27 in. (104 × 69 cm)
Photo by Phillip Dixon
Design by Christian Struzan

Seven (1995)
US 41 × 27 in. (104 × 69 cm)
(Advance)
Photo by Peter Sorrel
Design by De-La Erickson
Creative direction by Steve Reaves, Chris Pula,
Aimee Petta & Anthony Goldschmidt

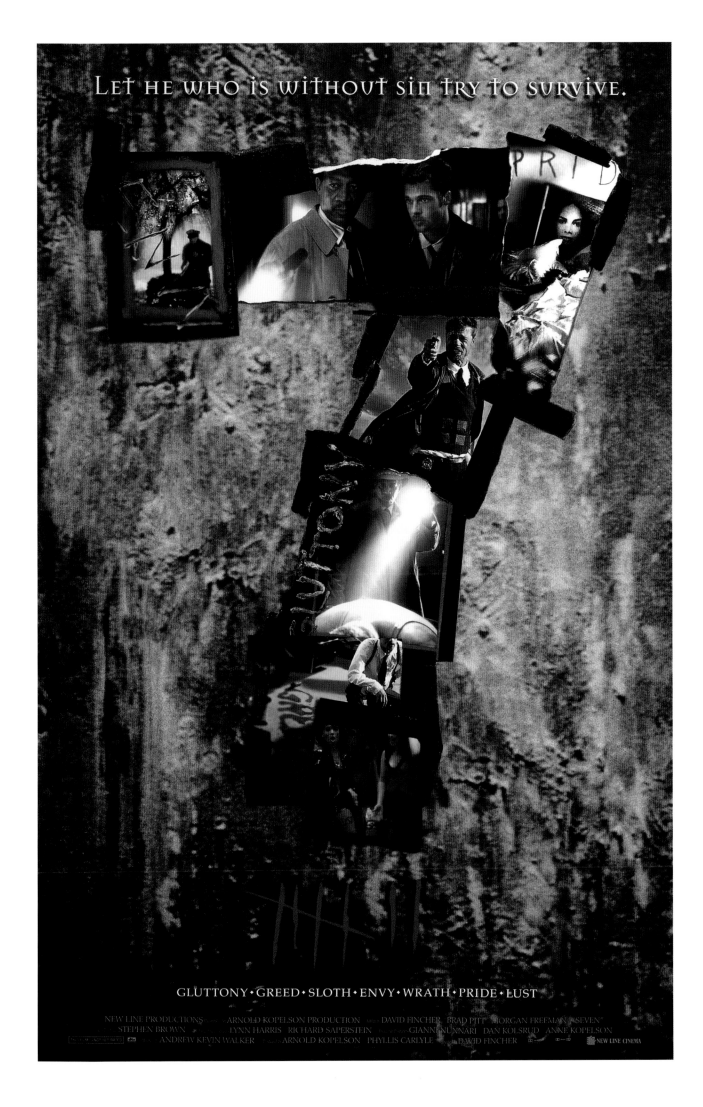

The Silence Of The Lambs (1991)
US 41 × 27 in. (104 × 69 cm)
(Advance – Hopkins)
Photo by Kevin Stapleton, Lee Varis & Ken Regan
Art direction and design by Dawn Teitelbaum

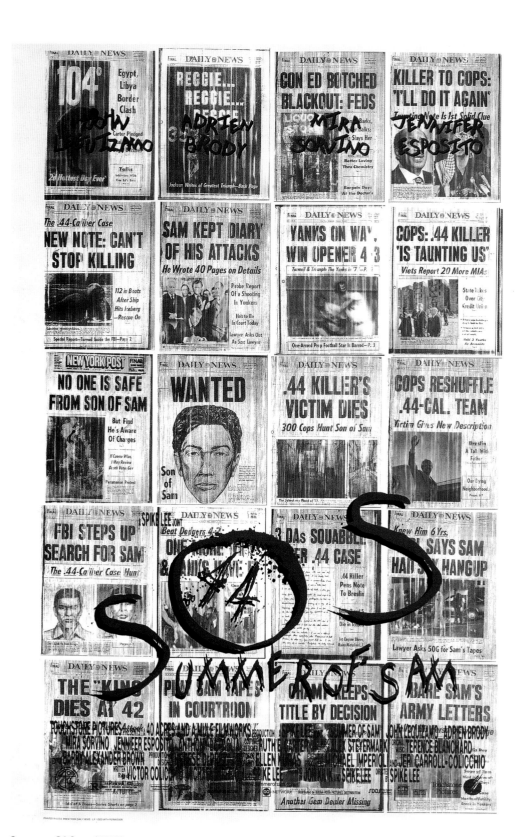

Summer Of Sam (1999)
US 41 × 27 in. (104 × 69 cm)
Design by Steve Nichols & John Sabel

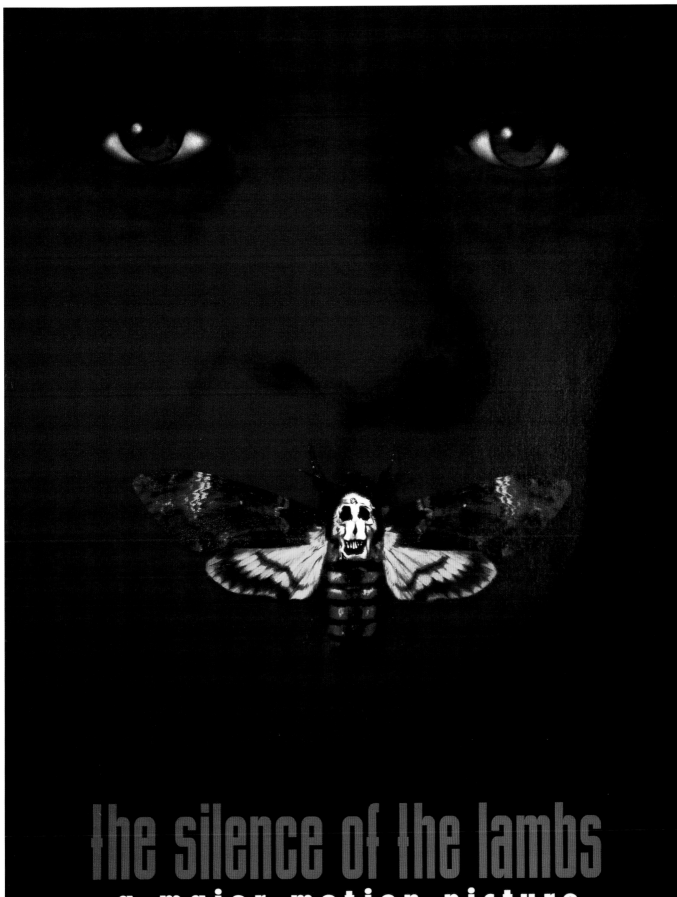

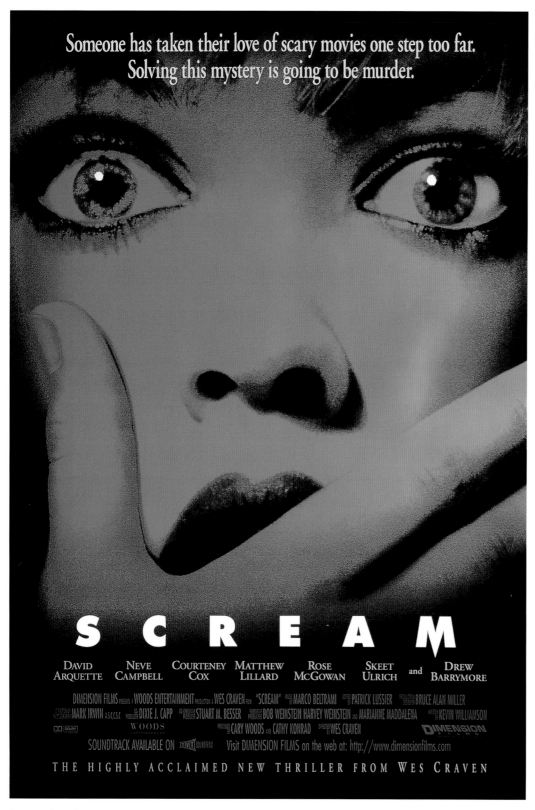

Scream (1996)
US 41 × 27 in. (104 × 69 cm)
Photo by Susan Schashter
Design by David Pearson
Creative direction by Tod Tarhan

The Blair Witch Project (1999)
US 41 × 27 in. (104 × 69 cm)
Art direction by Karen Crawford

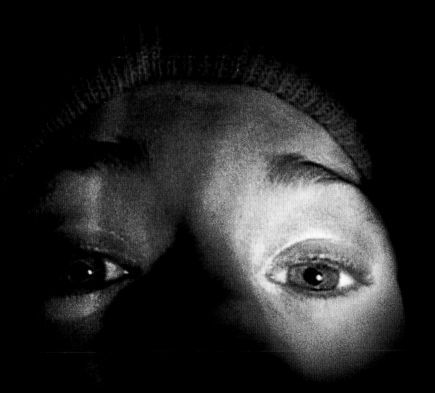

In October of 1994
three student filmmakers disappeared
in the woods near Burkittsville, Maryland
while shooting a documentary...

A year later their footage was found.

THE BLAIR WITCH PROJECT

ARTISAN ENTERTAINMENT PRESENTS A HAXAN FILMS PRODUCTION HEATHER DONAHUE MICHAEL WILLIAMS JOSHUA LEONARD "THE BLAIR WITCH PROJECT"
PRODUCTION DESIGNER BEN ROCK ART DIRECTOR RICARDO R. MORENO DIRECTOR OF PHOTOGRAPHY NEAL FREDERICKS MUSIC BY ANTONIO CORA EXECUTIVE PRODUCED BY BOB EICK AND KEVIN J. FOXE
CO-PRODUCED BY MICHAEL MONELLO PRODUCED BY GREGG HALE & ROBIN COWIE WRITTEN, DIRECTED AND EDITED BY DANIEL MYRICK & EDUARDO SANCHEZ

www.blairwitch.com

ARTISAN

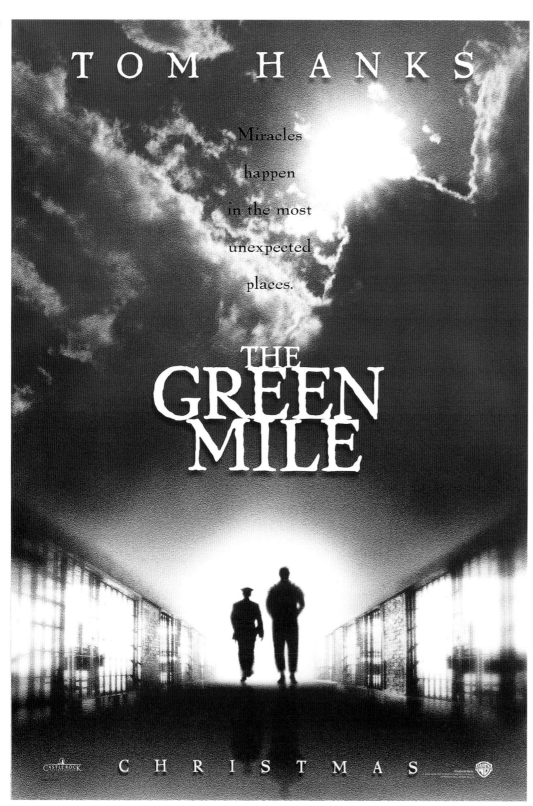

The Green Mile (1999)
US 41 × 27 in. (104 × 69 cm)
(Advance)
Creative direction by Anthony Goldschmidt & Mark Crawford

The Shawshank Redemption (1994)
US 41 × 27 in. (104 × 69 cm)
(Advance)
Photo by Peter Darley Miller
Creative direction by Anthony Goldschmidt

FEAR CAN HOLD YOU PRISONER.
HOPE CAN SET YOU FREE.

TIM ROBBINS MORGAN FREEMAN

THE
SHAWSHANK
REDEMPTION

CASTLE ROCK ENTERTAINMENT
FRANK DARABONT TIM ROBBINS MORGAN FREEMAN "THE SHAWSHANK REDEMPTION" BOB GUNTON WILLIAM SADLER
CLANCY BROWN GIL BELLOWS AND JAMES WHITMORE AS "BROOKS" THOMAS NEWMAN RICHARD FRANCIS-BRUCE
TERENCE MARSH ROGER DEAKINS, B.S.C. LIZ GLOTZER AND DAVID LESTER STEPHEN KING
FRANK DARABONT NIKI MARVIN FRANK DARABONT

THIS FALL

32

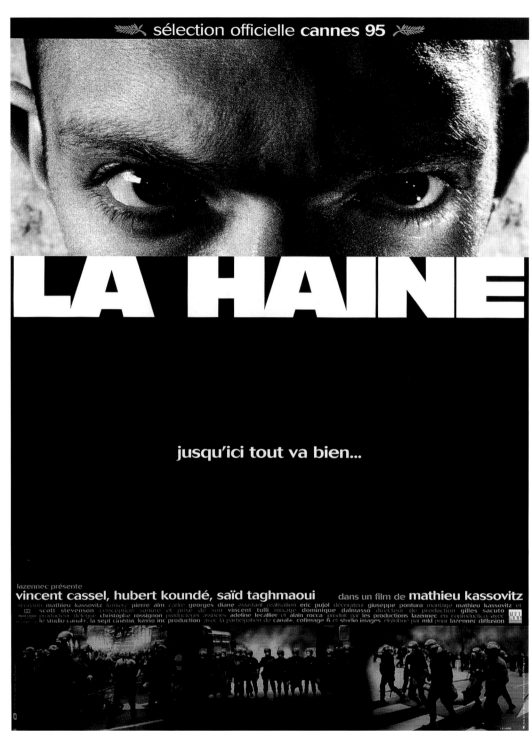

La Haine (Hate) (1995)
French 63 × 47 in. (160 × 119 cm)

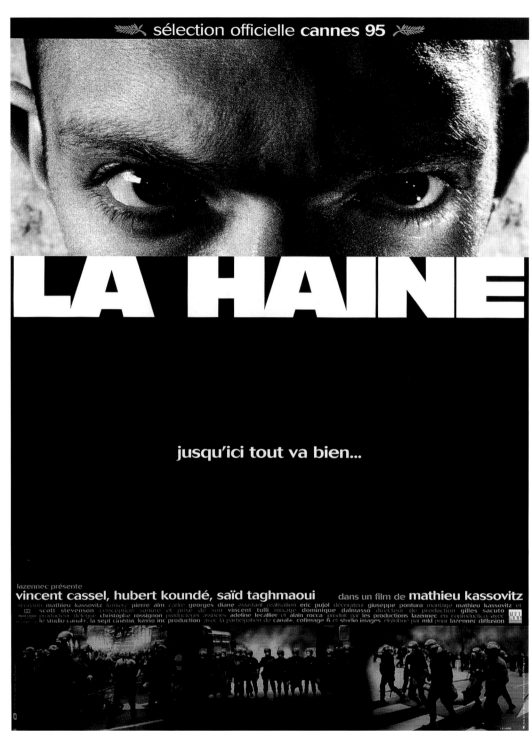

American History X (1998)
US 41 × 27 in. (104 × 69 cm)
Creative direction by Anthony
Goldschmidt & Mark Crawford

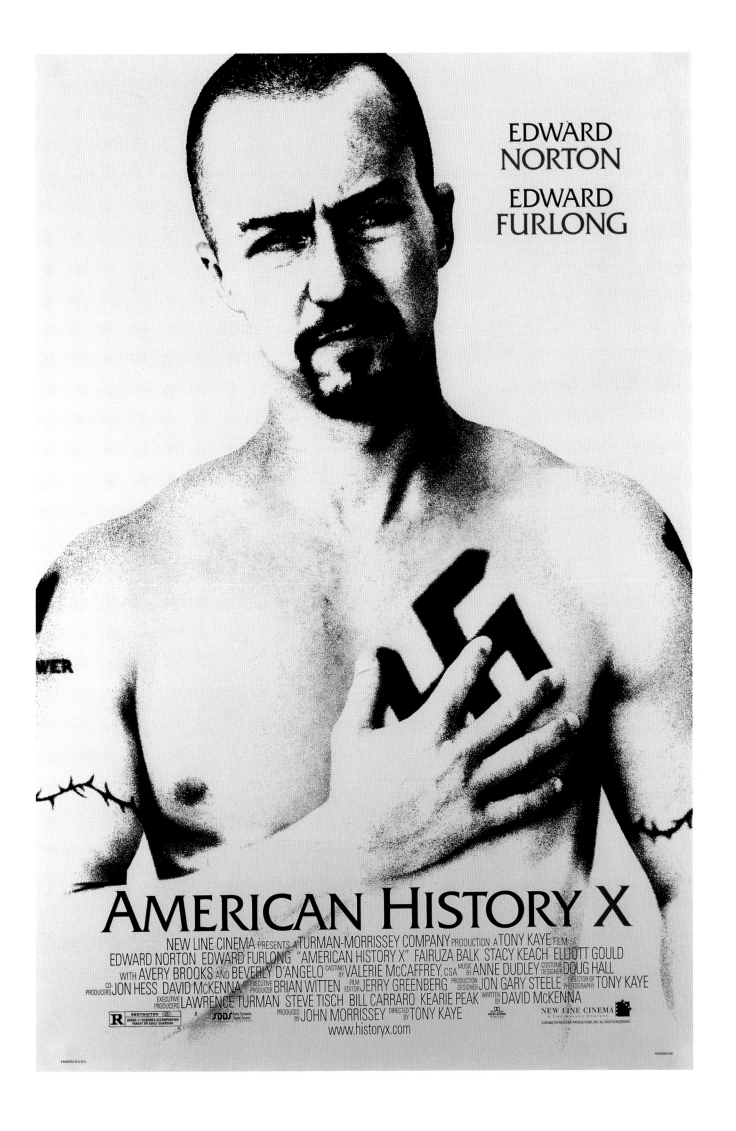

Naked Lunch (1991)
US 41 × 27 in. (104 × 69 cm)
Art by Steve Twigger

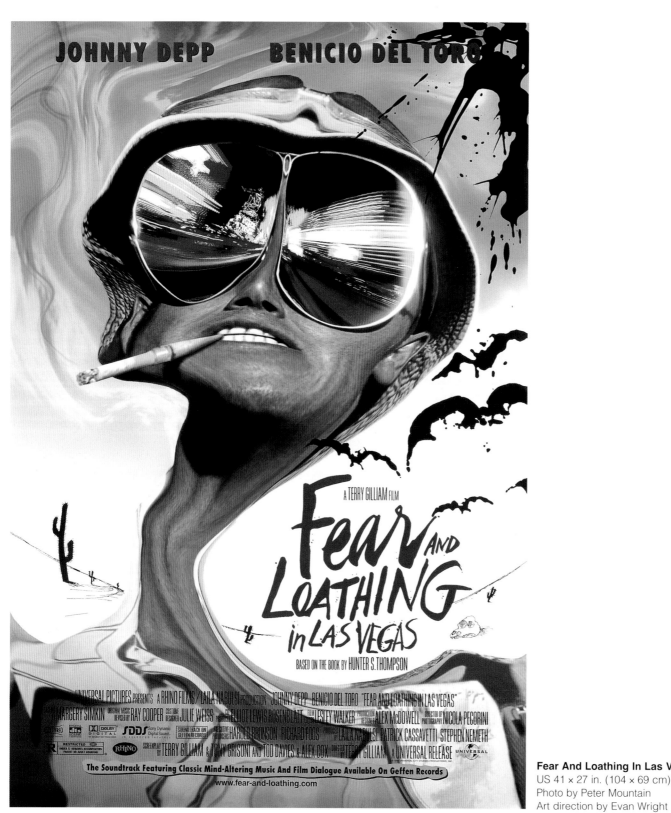

Fear And Loathing In Las Vegas (1998)
US 41 × 27 in. (104 × 69 cm)
Photo by Peter Mountain
Art direction by Evan Wright

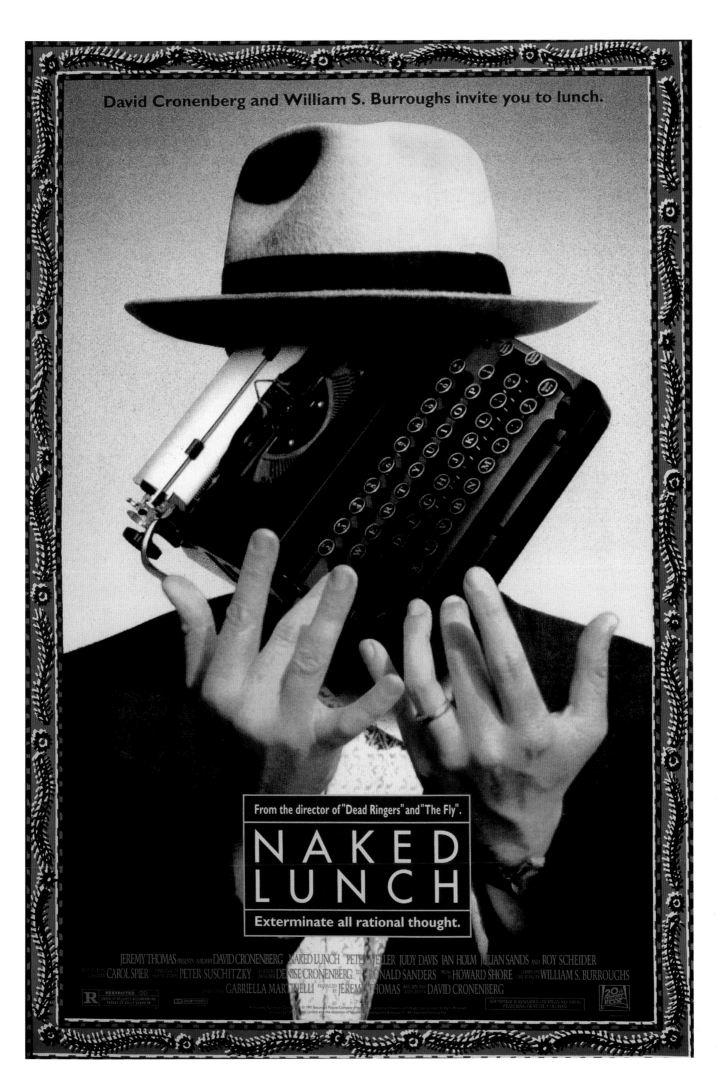

Jungle Fever (1991)
US 41 × 27 in. (104 × 69 cm)
(Advance)
Photo by Todd Gray
Design by Barbara Kolo

Malcolm X (1992)
US 41 × 27 in. (104 × 69 cm)
(Advance)
Design by Art Simms & Joel Wayne

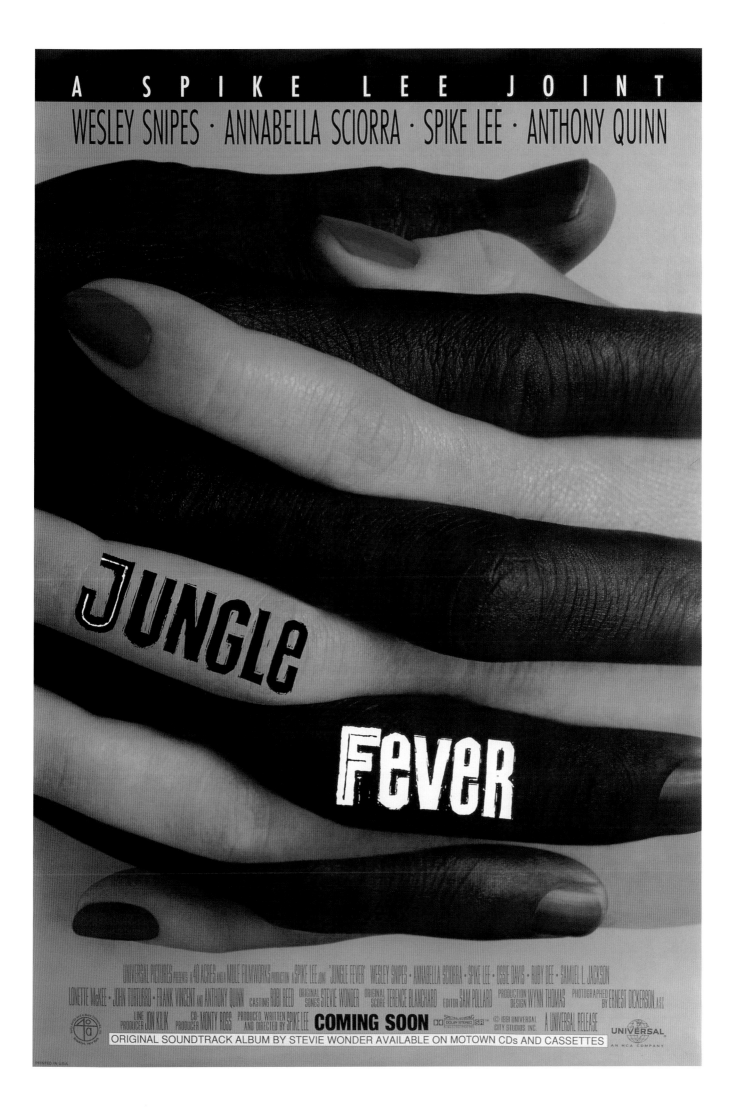

Basquiat (1996)
US 41 × 27 in. (10 4 × 69 cm)
Design and photography by Julian Schnabel
Creative direction by Tod Tarhan

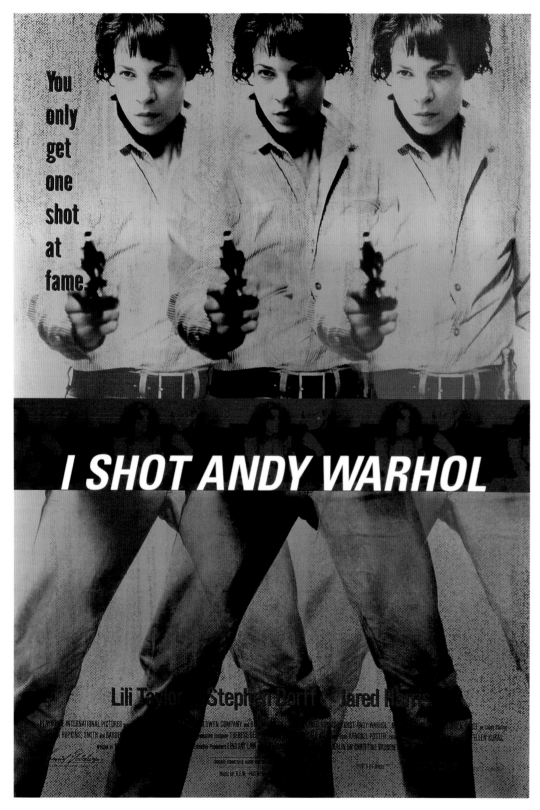

I Shot Andy Warhol (1996)
US 41 × 27 in. (104 × 69 cm)
Design by Grace Chang & Giuseppe Lipari

Dazed And Confused (1993)
US 41 × 27 in. (104 × 69 cm)
(Advance)
Design by Samantha Hart & Peter King Robbins

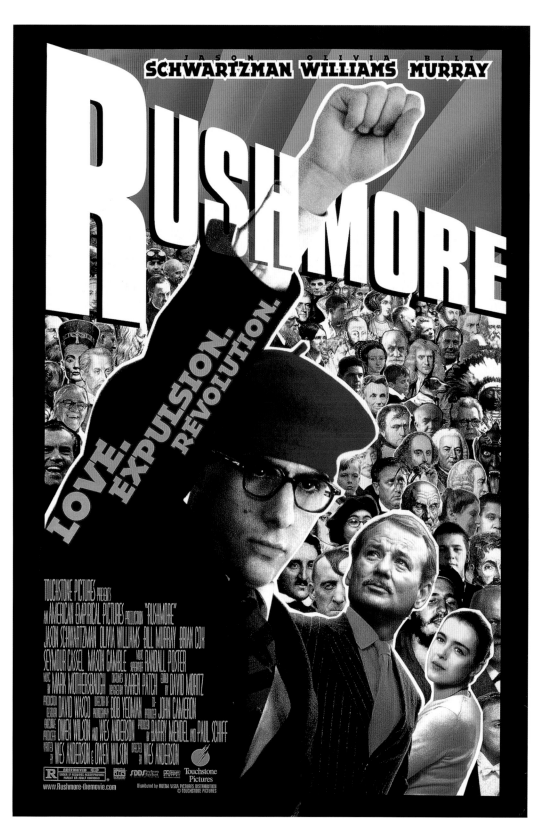

Rushmore (1998)
US 41 × 27 in. (104 × 69 cm)

Have A Nice Daze

Dazed and Confused

The Film Everyone Will Be Toking About

COMING THIS FALL

A GRAMERCY PICTURES RELEASE ©1993 Universal City Studios, Inc.

GRAMERCY
PICTURES

42

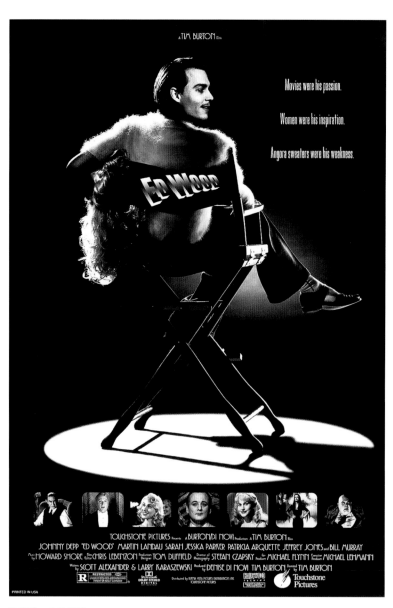

Ed Wood (1996)
US 41 × 27 in. (104 × 69 cm)
Photo by Susan Tenner
Design by Derek Shields

Edward Scissorhands (1990)
US 41 × 27 in. (104 × 69 cm)
(Advance Style A)

Mars Attacks! (1996)
US 41 × 27 in. (104 × 69 cm)
(Advance)
Art direction and design by Charles Reimers

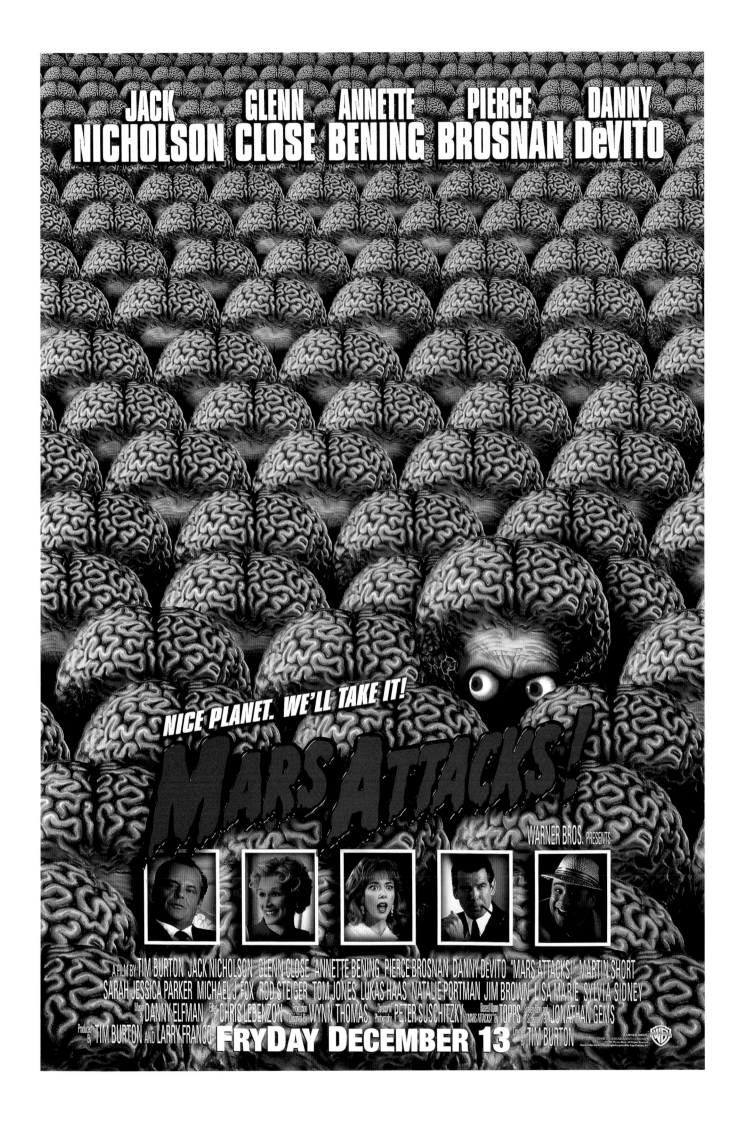

Idioterne / Idioci (The Idiots) (1998)
Polish 38 × 27 in. (97 × 69 cm)
Art by Wieslaw Walkuski

Art by Wieslaw Walkuski

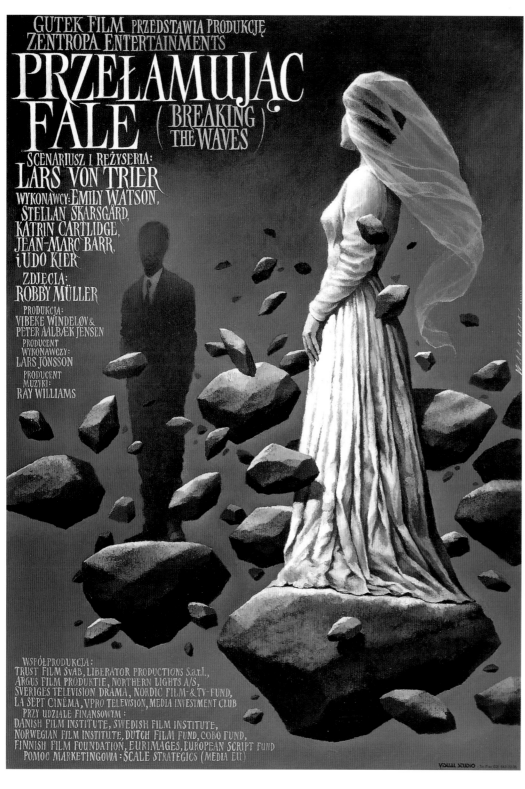

**Breaking The Waves /
Przelamujac Fale** (1996)
Polish 38 × 27 in. (97 × 69 cm)
Art by Wieslaw Walkuski

GUTEK FILM PRZEDSTAWIA PRODUKCJĘ ZENTROPA ENTERTAINMENTS 2

IDIOCI
(IDIOTERNE)

SCENARIUSZ i REŻYSERIA:
LARS von TRIER

DOGMA 2

WYKONAWCY: BODIL JØRGENSEN, JENS ALBINUS, ANNE LOUISE HASSING, TROELS LYBY, NIKOLAJ LIE KAAS, LOUISE MIERITZ, HENRIK PRIP, LUIS MESONERO, KNUD ROMER JØRGENSEN, TRINE MICHELSEN i ANNE-GRETHE BJARUP RIIS

DŹWIĘK: PER STREIT
MONTAŻ: MOLLY MALENE STENGAARD
SZEF PRODUKCJI: PETER AALBÆK JENSEN
PRODUCENT: VIBEKE WINDELØV
PRODUKCJA: ZENTROPA ENTERTAINMENTS 2 ApS i DR TV, DANISH BROADCASTING CORPORATION
POMOC DYSTRYBUCYJNA - EURIMAGES

VISUAL STUDIO tel. 642-22-35

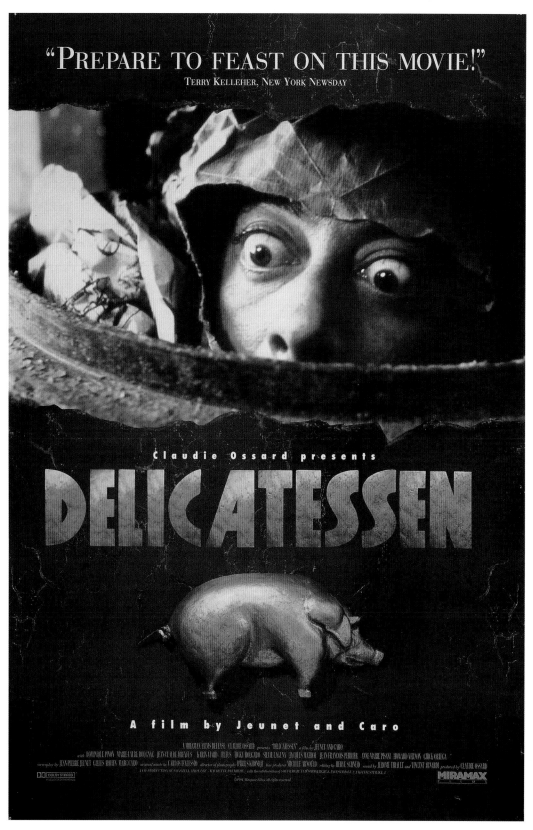

Delicatessen (1991)
US 41 × 27 in. (104 × 69 cm)

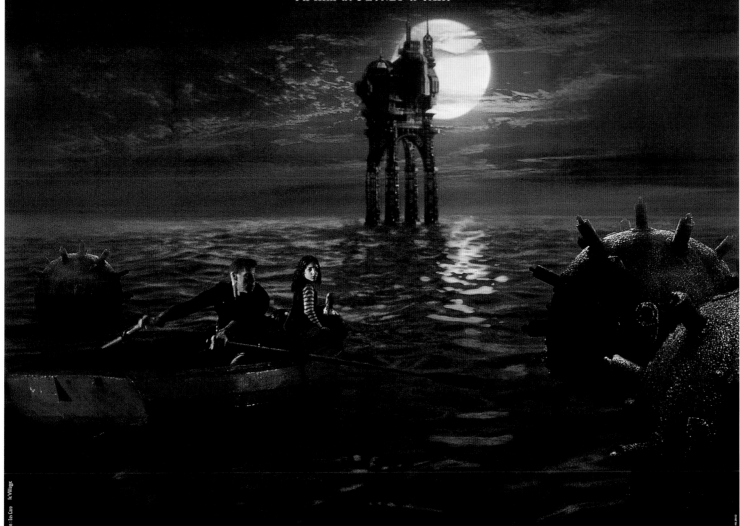

LUMIERE, LE STUDIO CANAL +, FRANCE 3 CINEMA présentent une production CLAUDIE OSSARD

La Cité des Enfants Perdus

Un film de JEUNET & CARO

Avec RON PERLMAN · Daniel EMILFORK · Judith VITTET · Dominique PINON · Jean-Claude DREYFUS · Geneviève BRUNET · Odile MALLET · Mireille MOSSE · Serge MERLIN
François HADJI-LAZARO · RUFUS · Ticky HOLGADO · et la participation de Jean-Louis TRINTIGNANT
Scénario de Gilles ADRIEN, Jean-Pierre JEUNET, Marc CARO · Dialogues de Gilles ADRIEN · Musique originale d'Angelo BADALAMENTI · Directeur de la photographie : Darius KHONDJI (AFC) · Decor : Jean RABASSE
Costumes : Jean-Paul GAULTIER · Son : Pierre EXCOFFIER · Montage : Hervé SCHNEID · Montage son : Gérard HARDY · Mixage : Vincent ARNARDI et Thierry LEBON · Effets spéciaux numériques : PITOF · Images de synthèse : Pierre BUFFIN
Directeur de production : Daniel SZUSTER · Produit par Claudie OSSARD Une coproduction CONSTELLATION, LUMIERE, LE STUDIO CANAL +, FRANCE 3 CINEMA
Avec la participation du Centre National de la Cinématographie, de Cofimage 4, Cofimage 5, Studio Image Canal +, et le soutien de la Procirep. Coproducteurs européens : Elias Querejeta (Espagne) et Tele Munchen (Allemagne)
Avec le soutien du Fonds Eurimages du Conseil de L'Europe et la collaboration du Club d'Investissement Média (Programme Média de l'Union Européenne)
Bande originale du film disponible sur CD et K7 - EAST WEST

DOLBY STEREO DIGITAL

UGC

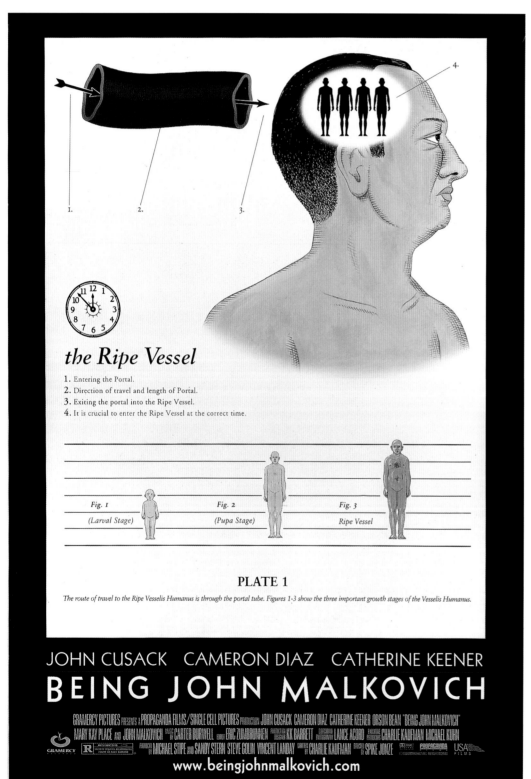

Being John Malkovich (1999)
US 41 × 27 in. (104 × 69 cm)
(Style B)
Art by Andy Jenkins
Creative direction by Paula Franceschi

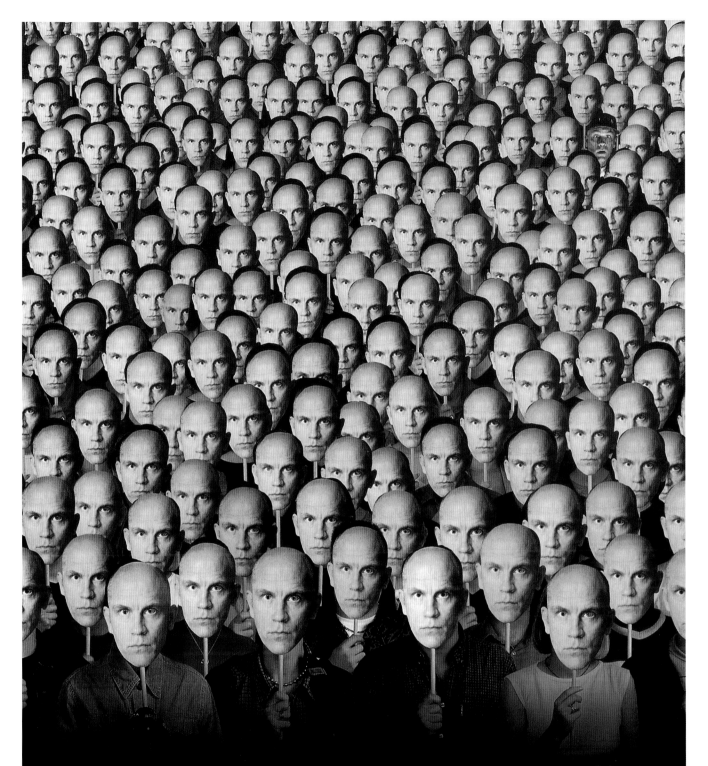

JOHN CUSACK CAMERON DIAZ CATHERINE KEENER

BEING JOHN MALKOVICH

A FILM DIRECTED BY SPIKE JONZE

www.beingjohnmalkovich.com

EVER WANTED TO BE SOMEONE ELSE?

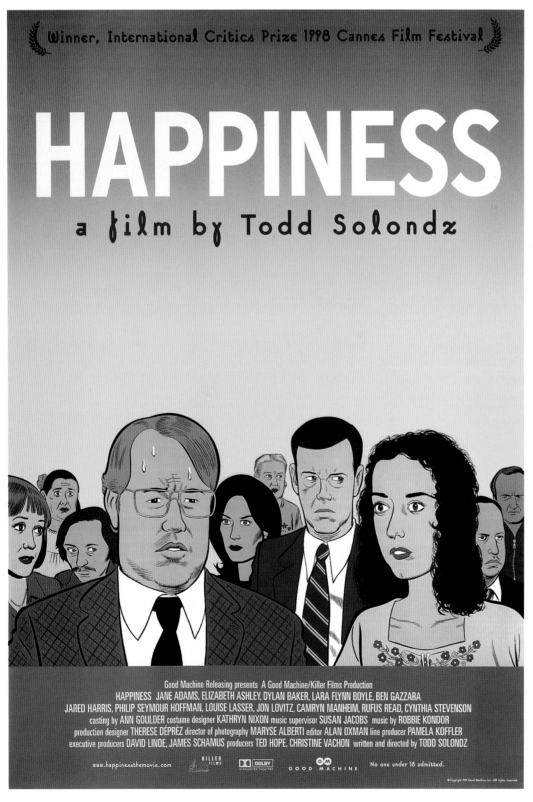

Happiness (1998)
US 41 × 27 in. (104 × 69 cm)

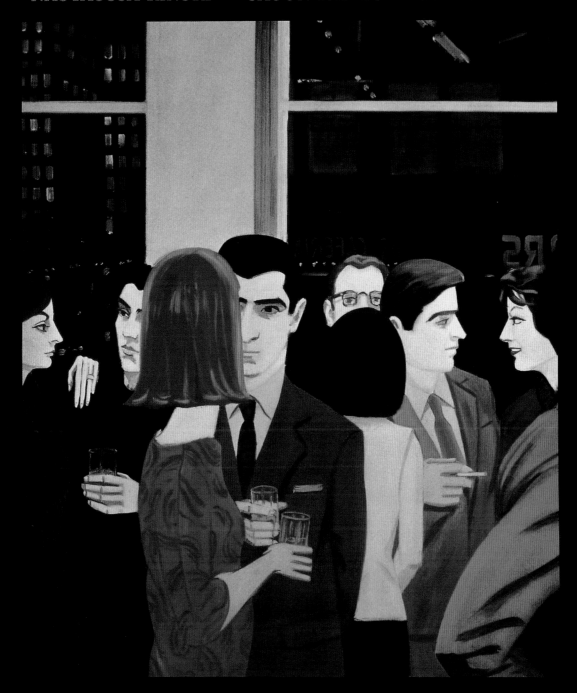

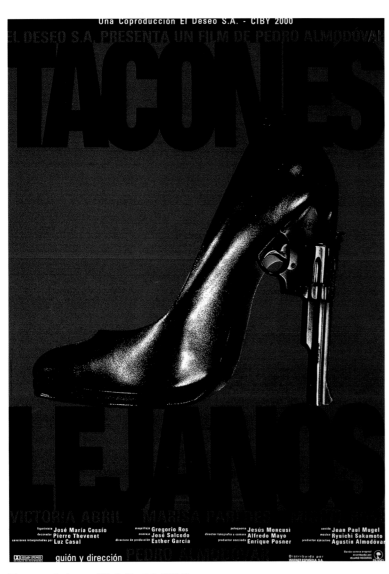

Tacones Lejanos (High Heels) (1991)
Spanish 39 × 27 in. (99 × 69 cm)
Design by Juan Gatti

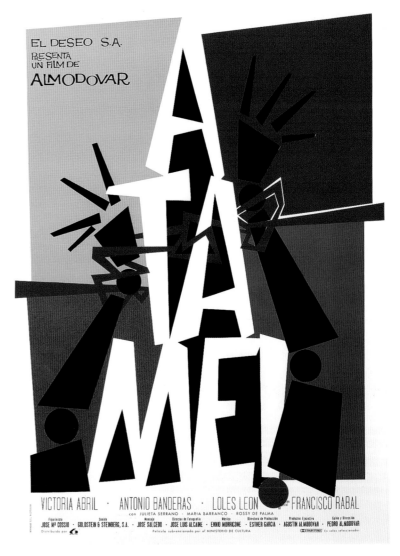

Atame! (Tie Me Up! Tie Me Down!) (1990)
Spanish 39 × 27 in. (99 × 69 cm)
Photo by Mimmo Cattarinich & Jorge Aparicio
Design by Juan Gatti

**La Flor De Mi Secreto
(The Flower Of My Secret)** (1995)
Spanish 39 × 27 in. (99 × 69 cm)
Design by Juan Gatti

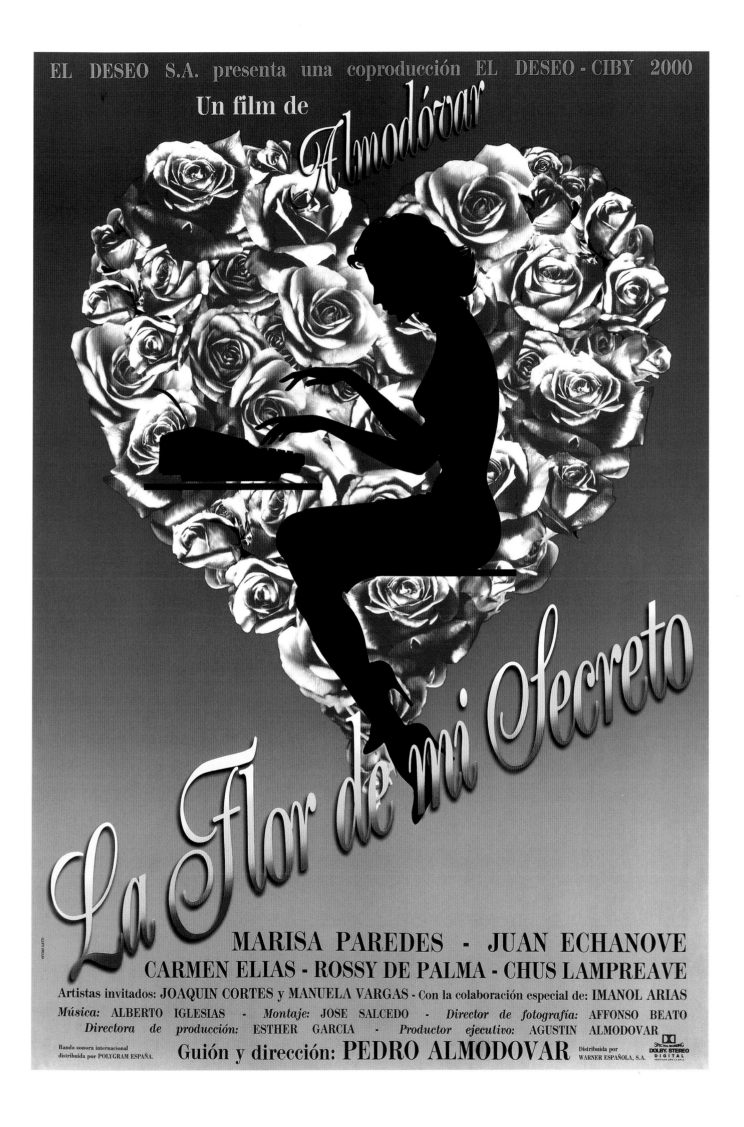

**Hachigatsu No Rapusodi /
Sierpniowa Rapsodia
(Rhapsody In August)** (1991)
Polish 38 × 27 in. (97 × 69 cm)
Art by Waldemar Swierzy

今、忘れられているとても大切なものが、ここにある。

黒澤明監督作品

松村達雄／香川京子／井川比佐志／所ジョージ／油井昌由樹／寺尾 聰／小林亜星／日下武史

ゼネラルプロデューサー：徳間康快／木暮剛平
製作：山本洋／入江雄三 ● プロデューサー：黒澤久雄
原作：内田百閒（福武書店「内田百閒全集」より）
脚本・監督：黒澤 明
撮影：齋藤孝雄／上田正治 ● 美術：村木与四郎
照明：佐野武治 ● 録音：西崎英雄
音楽：池辺晋一郎 ● 衣裳：黒澤和子
● 製作：大映株式会社 株式会社電通 株式会社黒澤プロダクション
● 製作協力：株式会社徳間書店 ● 配給：東宝株式会社

Madadayo (1993)
Japanese 30 × 20 in. (76 × 51 cm)
(Style B)
Art by Akira Kurosawa

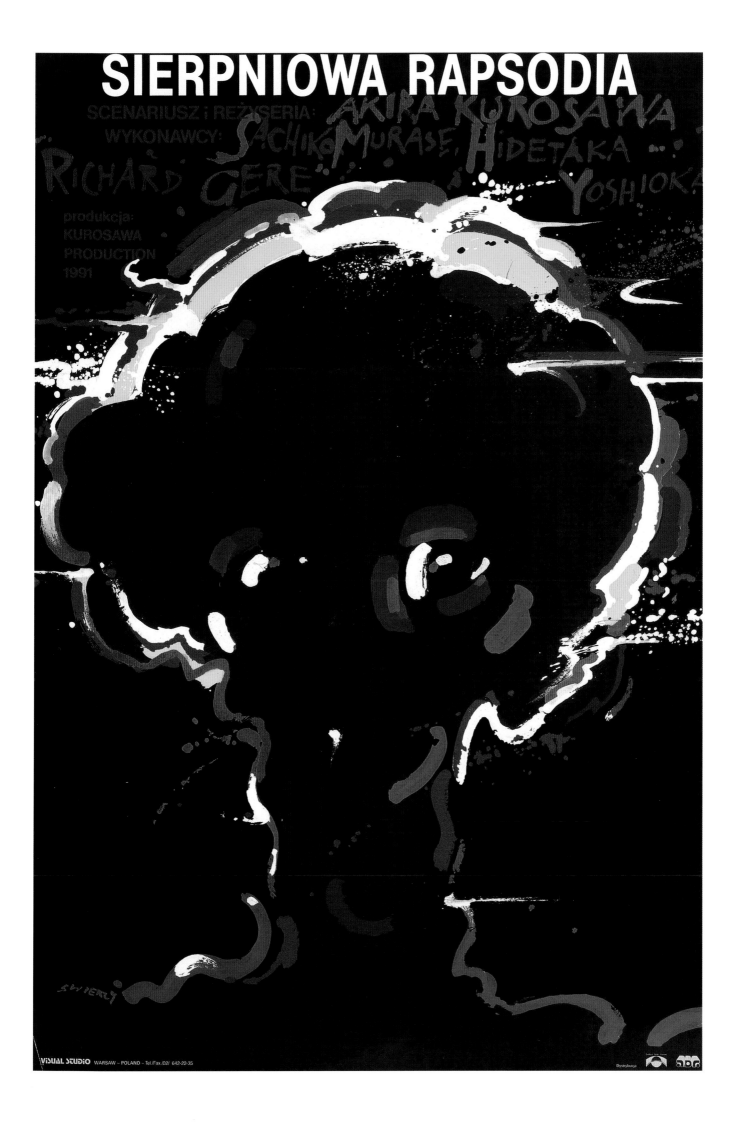

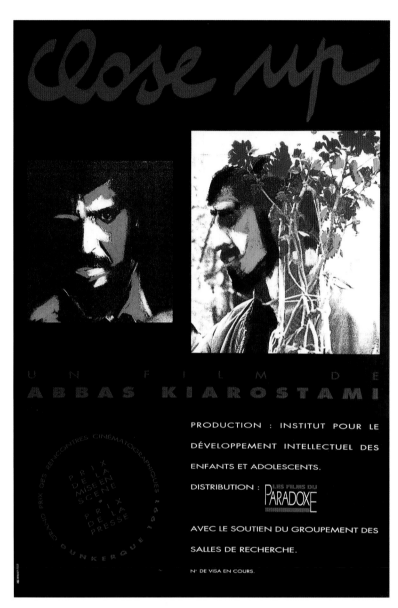

Nema-Ye Nazdik / Close Up (1990)
French 45 × 31 in. (114 × 79 cm)

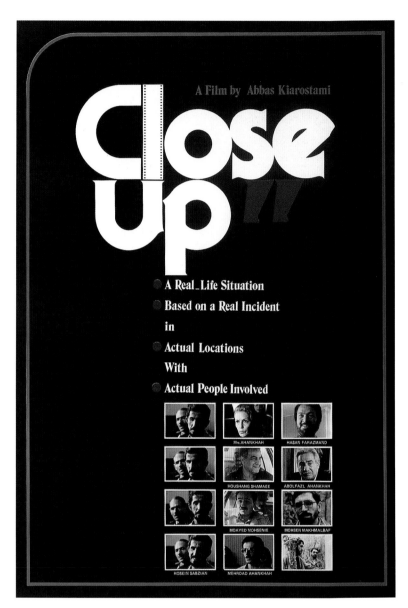

Nema-Ye Nazdik / Close Up (1990)
US 41 × 27 in. (104 × 69 cm)

Salaam Cinema / Salam Cinema (1995)
French 63 × 47 in. (160 × 119 cm)

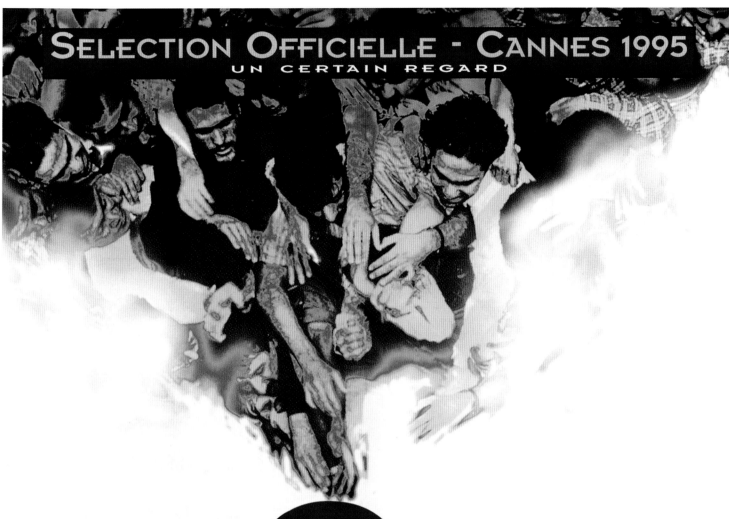

SALAM CINEMA

un film de
MOHSEN MAKHMALBAF

scénario,
réalisation,
montage
MOHSEN MAKHMALBAF
image
MAHMOUD KALARI
son
NEZAM KIYAÏ
musique
SHAHRDAD ROHANI
assistants réalisateur
**MOHARAM ZINALZADEH,
BAHRAM AZIMPOUR**
producteur exécutif
A. LAVASANI
producteur
**GREEN FILM HOUSE
ABBAS RANDJBAR**

DISTRIBUÉ PAR MKL POUR MK2 DIFFUSION

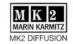

MARIN KARMITZ
MK2 DIFFUSION

58

Shadows And Fog (1992)
US 41 × 27 in. (104 × 69 cm)

Mighty Aphrodite (1995)
US 41 × 27 in. (104 × 69 cm)
(Style B)

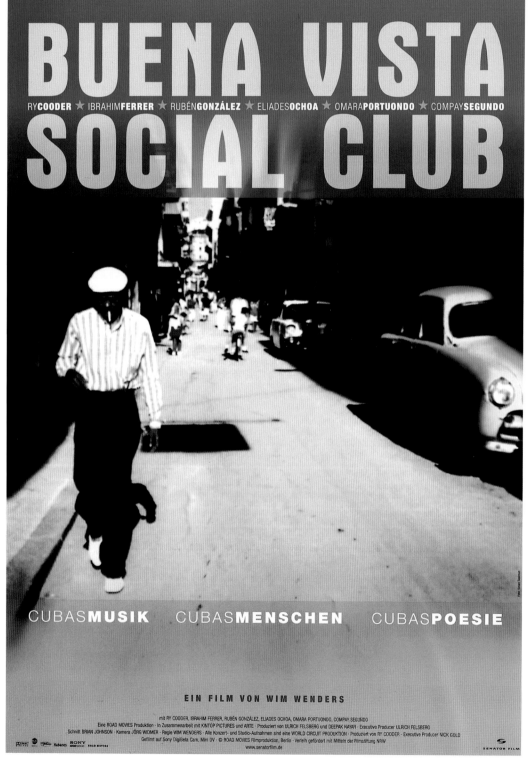

Buena Vista Social Club (1999)
German 33 × 23 in. (84 × 58 cm)
Photo by Susan Titelman
Design by Patricia Folgar

THE LEGACY OF A FAMOUS JAZZ PHOTOGRAPH

A Great Day In Harlem

A Film by JEAN BACH

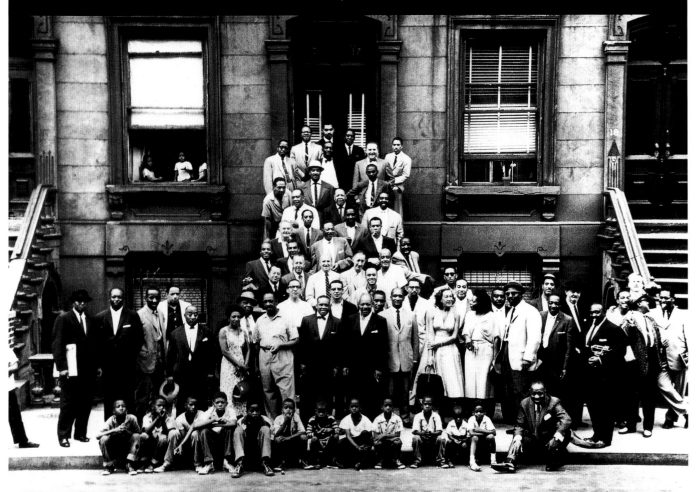

Photo ©1958 ART KANE. Courtesy of Staley-Wise Gallery, NY

WITH:

DIZZY GILLESPIE
ART BLAKEY
ART FARMER
CHUBBY JACKSON
MARIAN MCPARTLAND
EDDIE LOCKE

ERNIE WILKINS
MONA HINTON
ROBERT BENTON
SONNY ROLLINS
HANK JONES
JOHNNY GRIFFIN
SCOVILLE BROWNE

TAFT JORDAN, JR.
BUD FREEMAN
GERRY MULLIGAN
ELAINE LORILLARD
ROBERT ALTSCHULER
STEVE FRANKFURT
BUCK CLAYTON

HORACE SILVER
MILT HINTON
MAX KAMINSKY
BENNY GOLSON
NAT HENTOFF
MIKE LIPSKIN
ART KANE

Introductory Narration By: QUINCY JONES

Photographed by **STEVE PETROPOULOS** Edited by **SUSAN PEEHL** Co-Produced by **MATTHEW SEIG** Produced by **JEAN BACH**

The Commitments (1991)
US 41 × 27 in. (104 × 69 cm)
Photo by David Appleby
Design by Rick Lynch

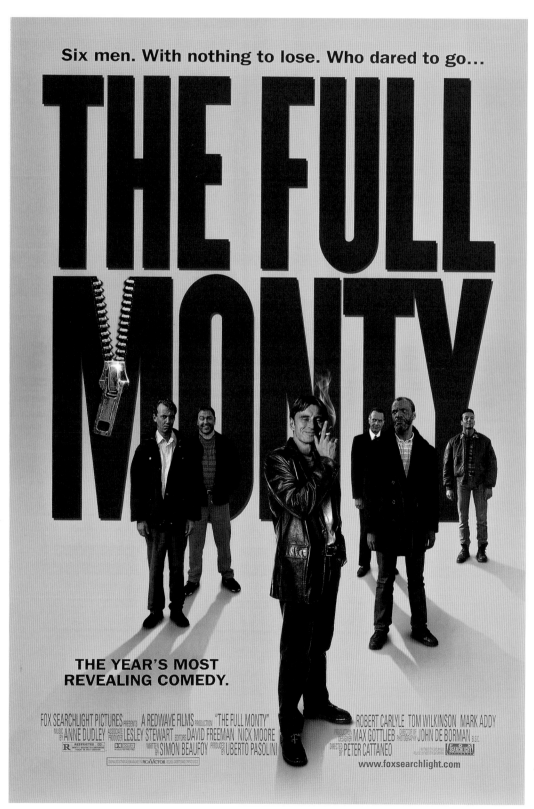

The Full Monty (1997)
US 41 × 27 in. (104 × 69 cm)
Photo by Robert Sebree & Tom Hilton

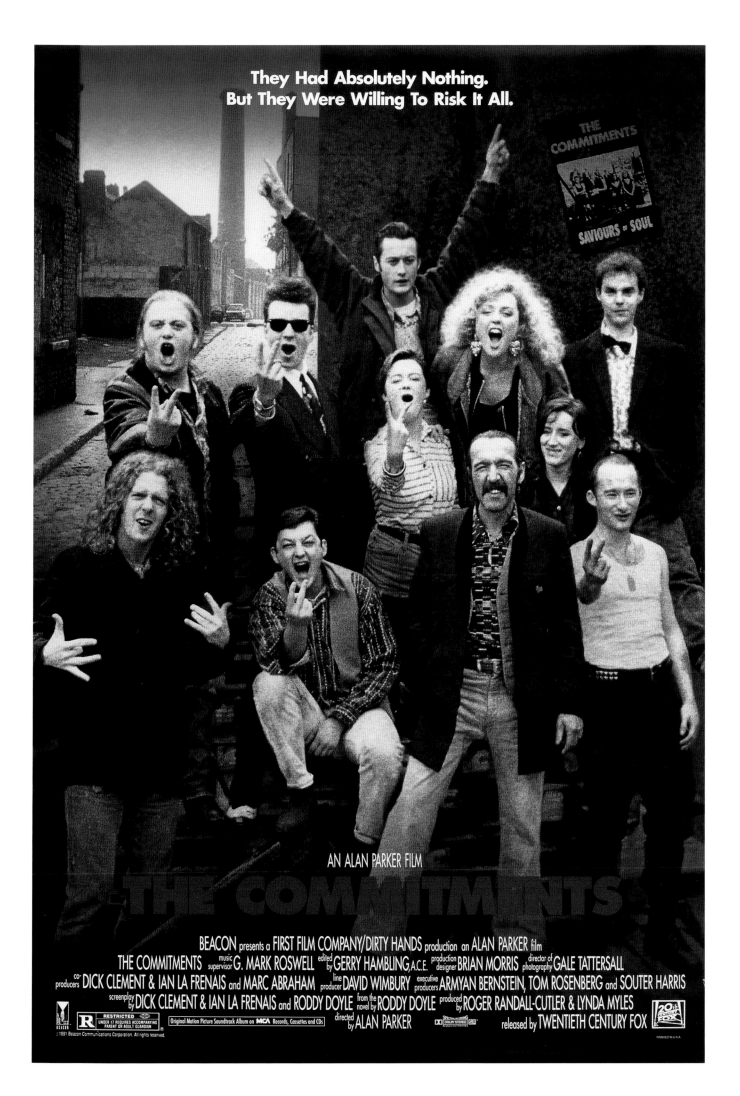

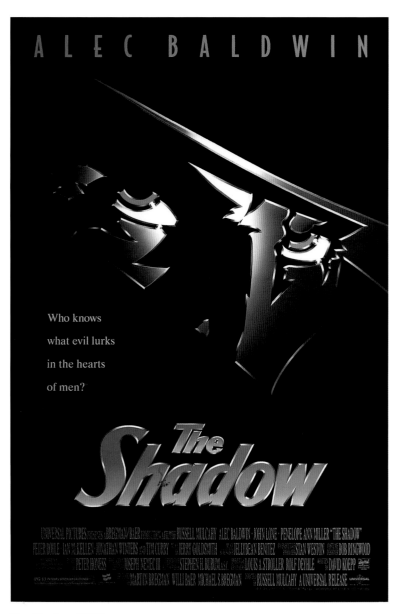

The Shadow (1994)
US 41 × 27 in. (104 × 69 cm)
Art by David Reneric & John Millerburg
Design by David Reneric

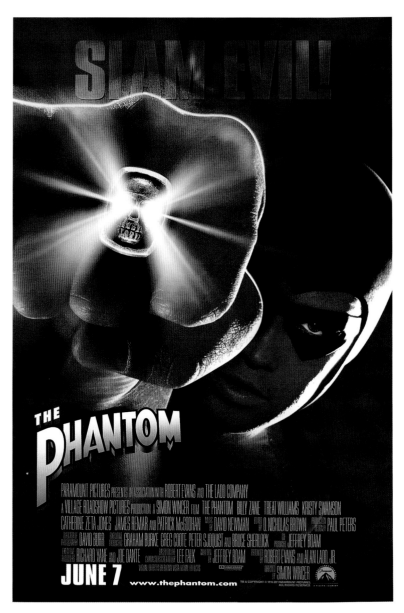

The Phantom (1996)
US 41 × 27 in. (104 × 69 cm)
Photo by Lee Varis
Design by Tracy Weston

The Rocketeer (1991)
US 41 × 27 in. (104 × 69 cm)
(First Advance)
Art by John Mattos
Creative direction by Robert Jahn

ROCKETEER

Saving Private Ryan (1998)
US 41 × 27 in. (104 × 69 cm)
(Advance)
Creative direction by David Sameth

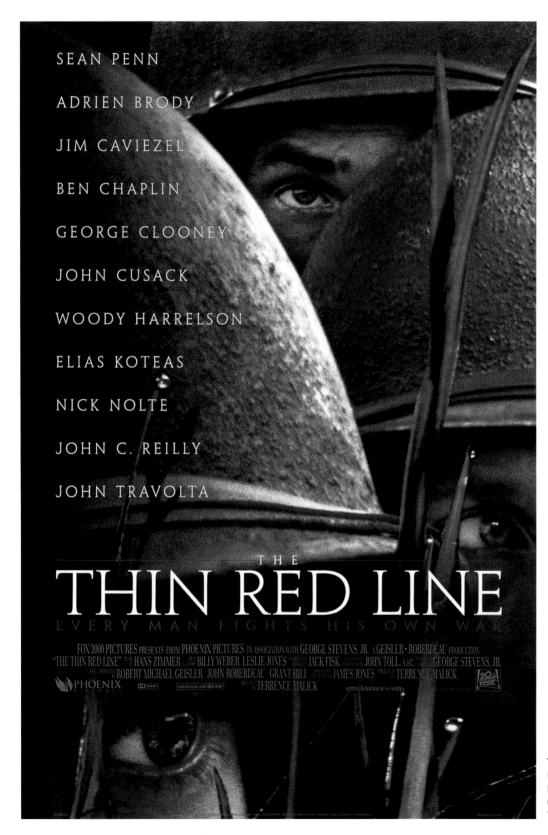

The Thin Red Line (1998)
US 41 × 27 in. (104 × 69 cm)
Photo by Merie Wallace
Creative direction by
Tony Stella & Christopher Pawlak

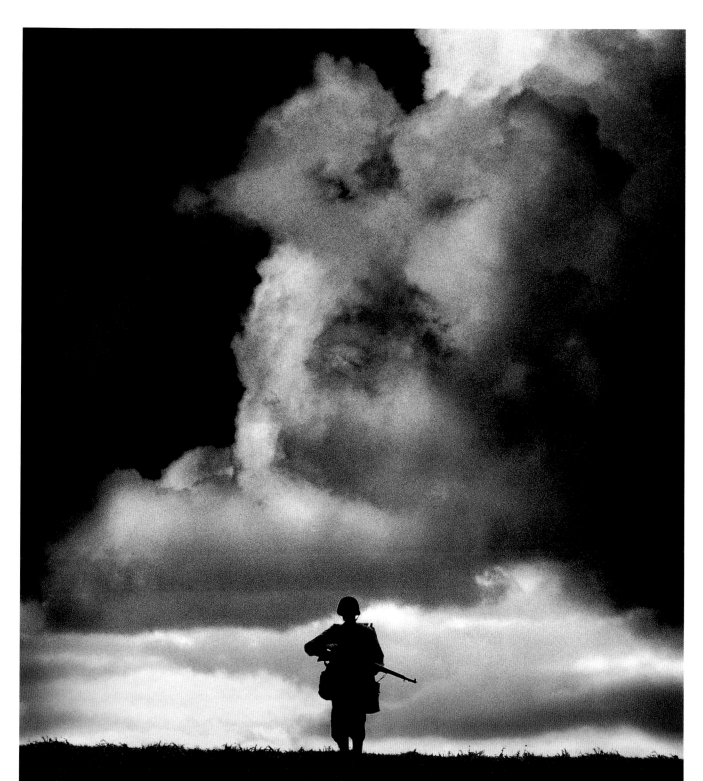

A STEVEN SPIELBERG FILM

tom hanks

saving private ryan

the mission is a man.

DREAMWORKS PICTURES AND PARAMOUNT PICTURES PRESENT
AN AMBLIN PRODUCTION IN ASSOCIATION WITH MARK GORDON AND GARY LEVINSOHN TOM HANKS "SAVING PRIVATE RYAN"
EDWARD BURNS MATT DAMON TOM SIZEMORE MUSIC BY JOHN WILLIAMS COSTUME DESIGNER JOANNA JOHNSTON FILM EDITOR MICHAEL KAHN, A.C.E.
PRODUCTION DESIGNER TOM SANDERS DIRECTOR OF PHOTOGRAPHY JANUSZ KAMINSKI, A.S.C. PRODUCED BY STEVEN SPIELBERG & IAN BRYCE AND MARK GORDON & GARY LEVINSOHN
 WRITTEN BY ROBERT RODAT DIRECTED BY STEVEN SPIELBERG DREAMWORKS PICTURES

PRINTED IN U.S.A.

DISTRIBUTED BY DREAMWORKS DISTRIBUTION L.L.C. TM & © 1997 DREAMWORKS L.L.C. and PARAMOUNT PICTURES CORPORATION

Schindler's List (1993)
US 41 × 27 in. (104 × 69 cm)
Photo by Morton Shapiro
Design by Georgia Young

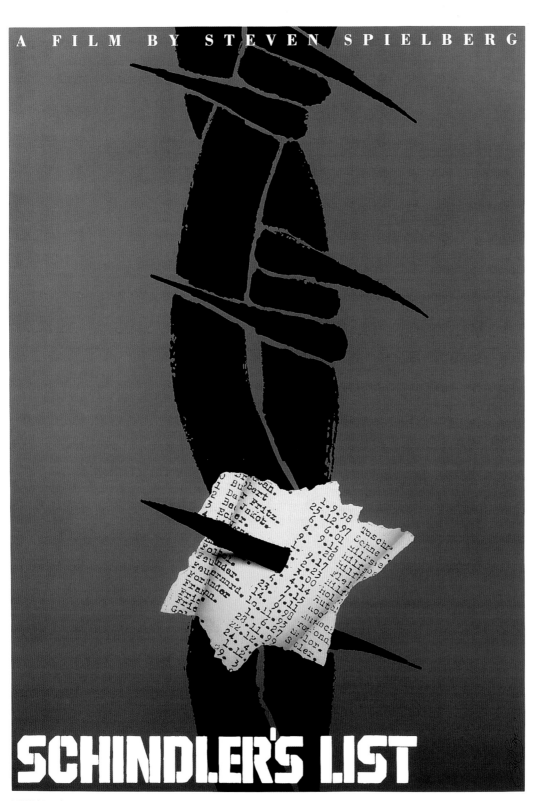

Schindler's List (1993)
US 41 × 27 in. (104 × 69 cm)
(Unused)
Art by Saul Bass

Terminator 2: Judgement Day (1991)
US 41 × 27 in. (104 × 69 cm)

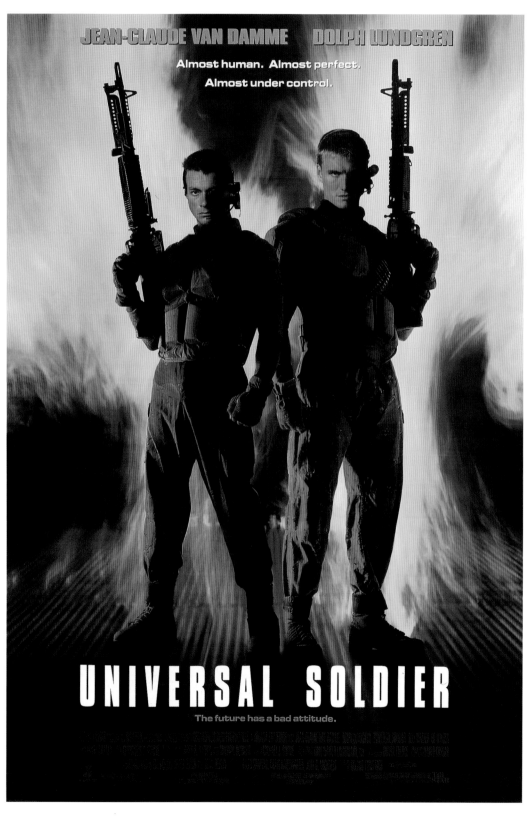

Universal Soldier (1992)
US 41 × 27 in. (104 × 69 cm)
Photo by Timothy White & Randee St. Nichols
Design by Henry Lehn & David Jewitt

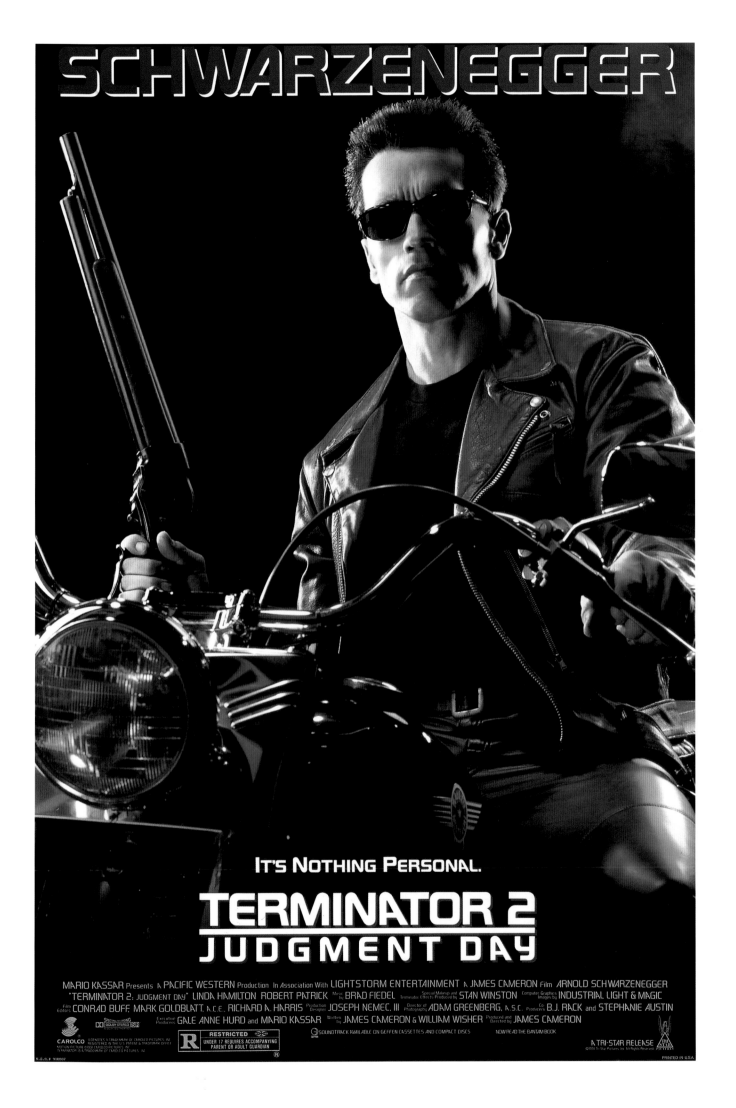

The Matrix (1999)
US 41 × 27 in. (104 × 69 cm)
Creative direction by Joel Wayne

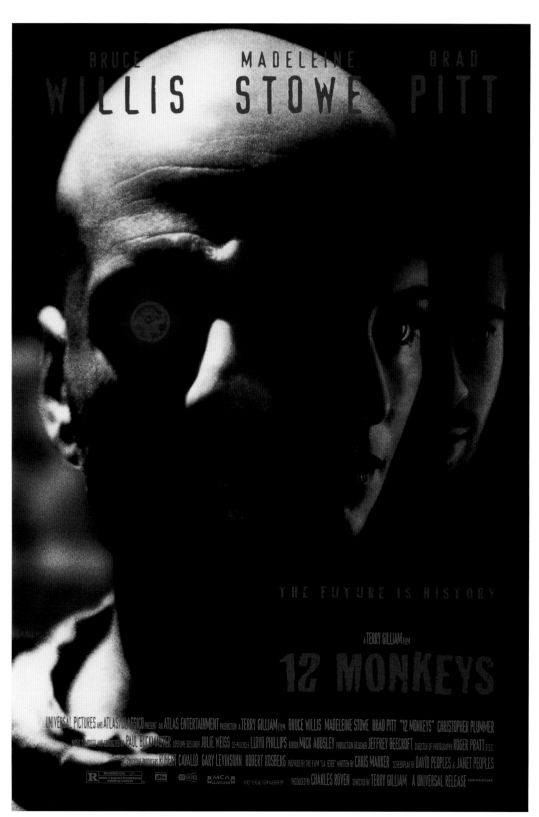

12 Monkeys (1995)
US 41 × 27 in. (104 × 69 cm)
Photo by Phillip Caruso
Art direction by Evan Wright

The Crow (1994)
US 41 × 27 in. (104 × 69 cm)
Creative direction by Anthony Goldschmidt
Art direction by Brian James

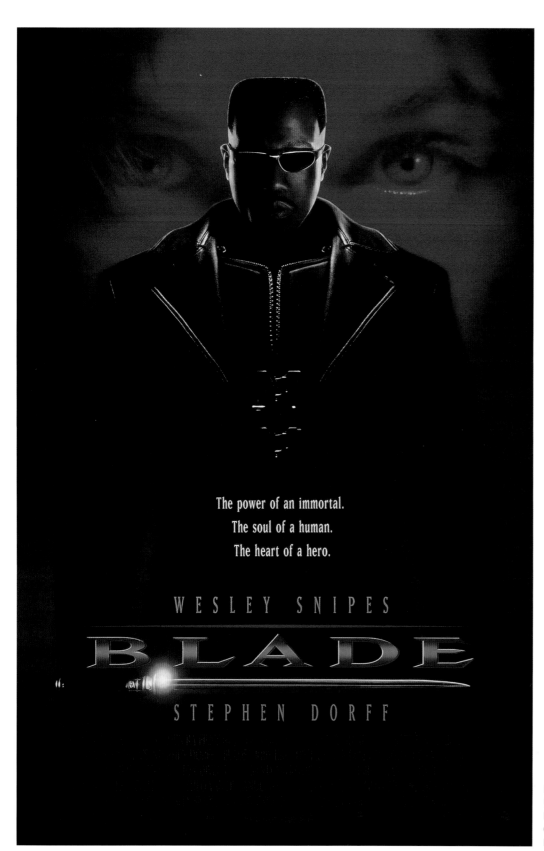

The power of an immortal.
The soul of a human.
The heart of a hero.

WESLEY SNIPES

BLADE

STEPHEN DORFF

Blade (1998)
US 41 × 27 in. (104 × 69 cm)
Photo by Robert Sebree
Creative direction by
Lori Drazen & Tracy Weston

BRANDON LEE

BELIEVE

IN

ANGELS

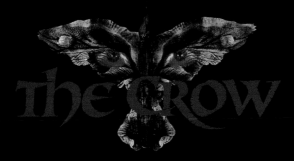

Jurassic Park (1993)
US 41 × 27 in. (104 × 69 cm)
(Advance)
Art by Chip Kidd
Design by Tom Martin
Creative direction by David Sameth

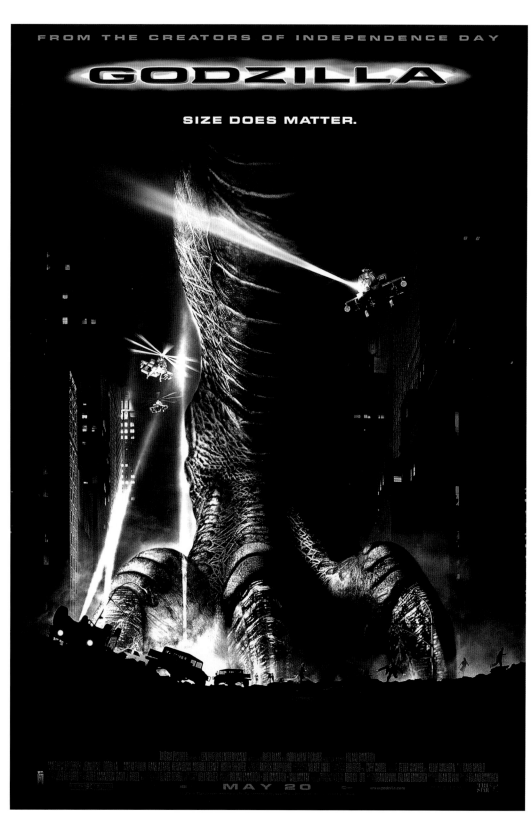

Godzilla (1998)
US 40 × 27 in. (102 × 69 cm)
(Advance)
Design by Hector Rojas
Creative direction by Martin Gueulette

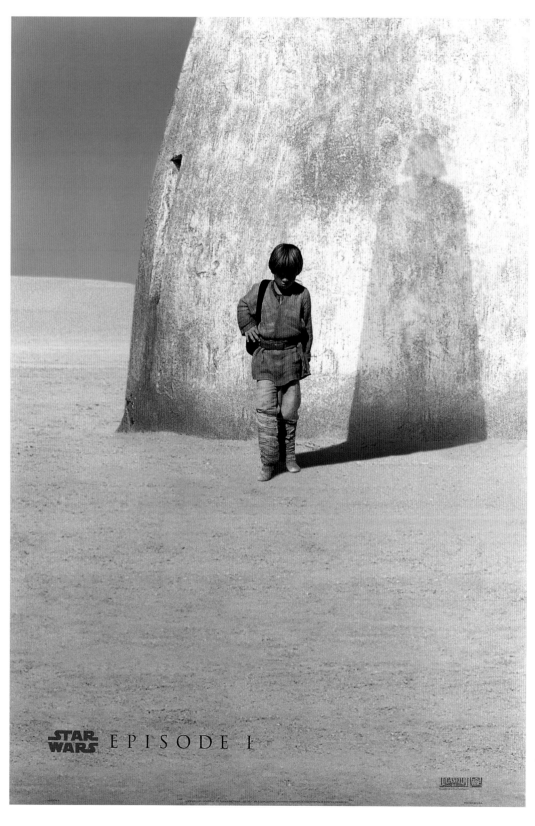

Star Wars: Episode 1 –
The Phantom Menace (1999)
US 40 × 27 in. (76 × 102 cm)
(Advance Style A)
Design by Ellen Lee

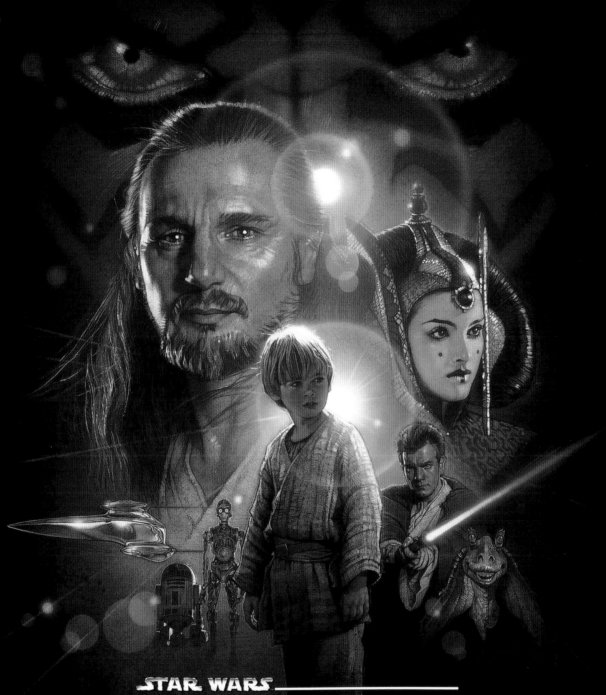

EVERY SAGA HAS A BEGINNING

STAR WARS

EPISODE I

THE PHANTOM MENACE

STAR WARS EPISODE I THE PHANTOM MENACE
Starring LIAM NEESON EWAN McGREGOR NATALIE PORTMAN JAKE LLOYD IAN McDIARMID
Co-starring ANTHONY DANIELS KENNY BAKER PERNILLA AUGUST FRANK OZ
Music by JOHN WILLIAMS Produced by RICK McCALLUM

Written and Directed by
GEORGE LUCAS

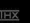

Special Visual Effects and Animation by INDUSTRIAL LIGHT & MAGIC
A LUCASFILM LTD. Production — A TWENTIETH CENTURY FOX Release
Soundtrack Available on SONY CLASSICAL Read the Novel from DEL REY BOOKS
WWW.STARWARS.COM

GoldenEye (1995)
US 41 × 27 in. (104 × 69 cm)
(Advance)
Photo by Terry O'Neil

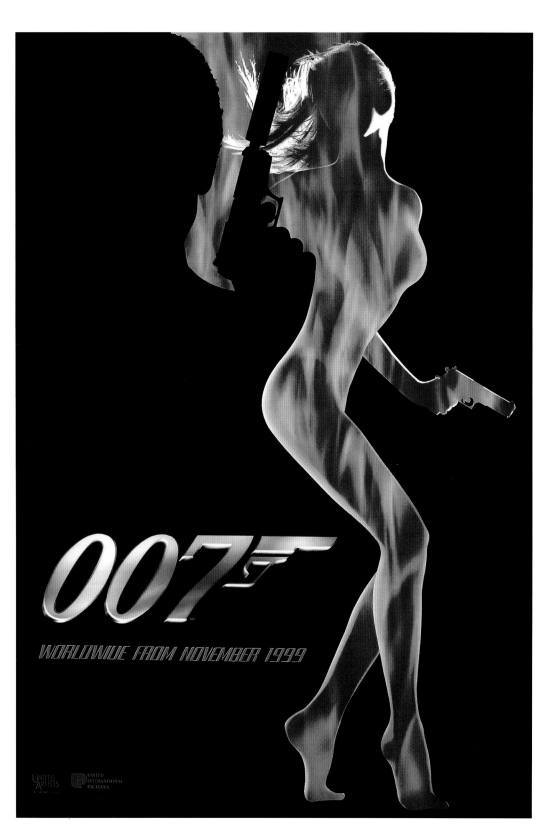

The World Is Not Enough (1999)
US 41 × 27 in. (104 × 69 cm)
(Advance)
Photo by Linda Posnick
Design by Diane Reynolds

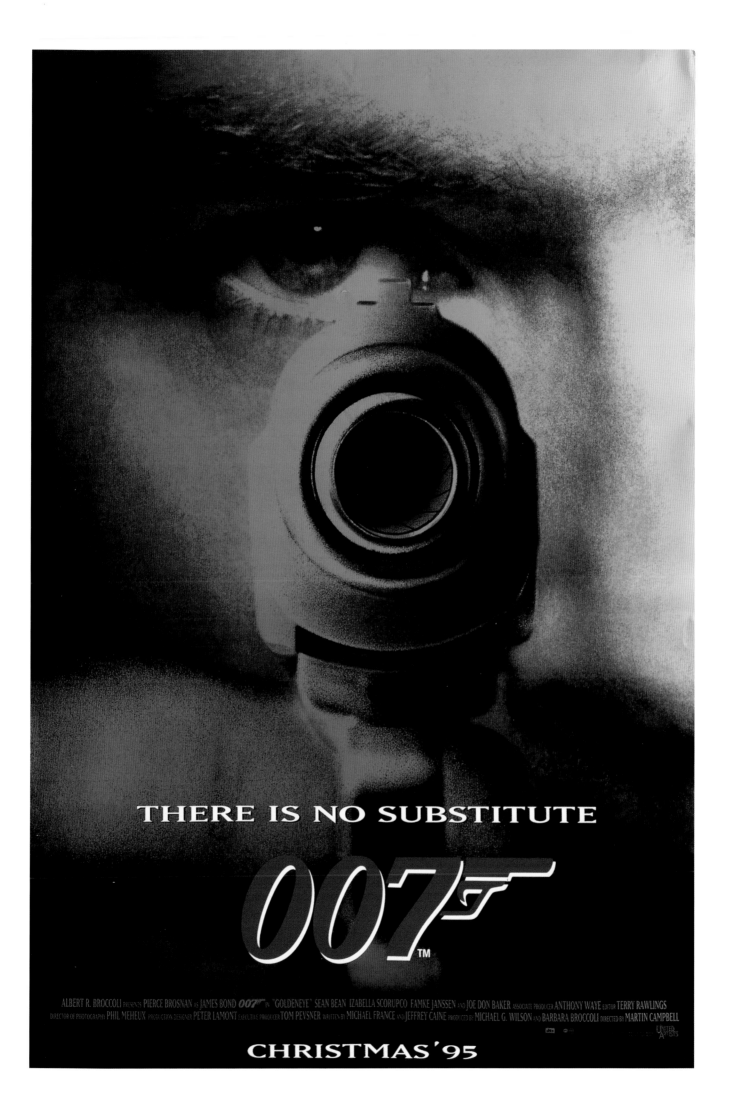

Thelma And Louise (1991)
US 41 × 27 in. (104 × 69 cm)
Art direction by Anthony Goldschmidt
Design by Jennifer Luth

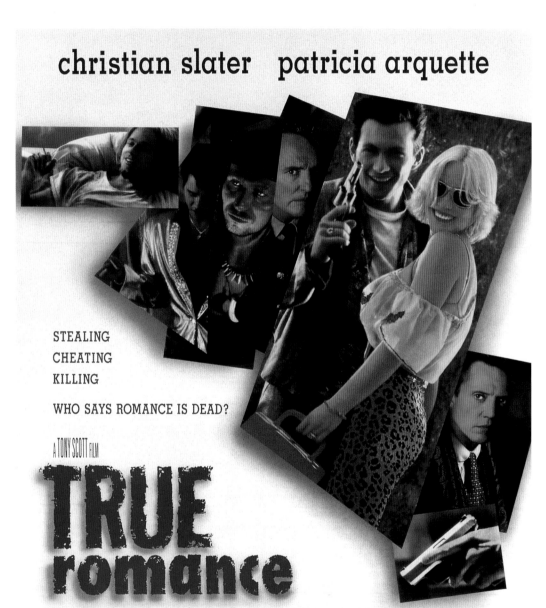

True Romance (1993)
US 41 × 27 in. (104 × 69 cm)
Photo by Timothy White
Design by Tom Brothers & Linda Joffe

Forrest Gump (1994)
US 41 × 27 in. (104 × 69 cm)
(Advance)
Photo by E. J. Camp
Design by Robert Tepper

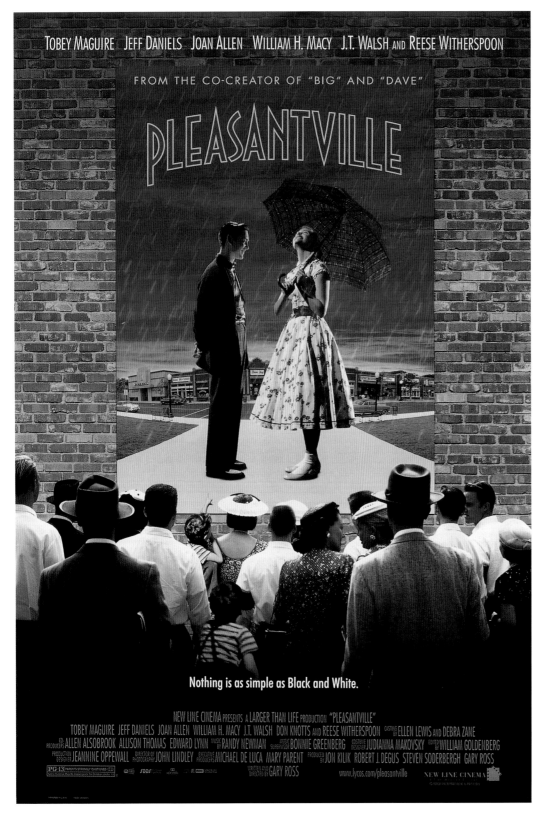

Pleasantville (1998)
US 41 × 27 in. (104 × 69 cm)

The world
will never be the same
once you've
seen it through the eyes of
Forrest Gump.

Tom Hanks is Forrest Gump

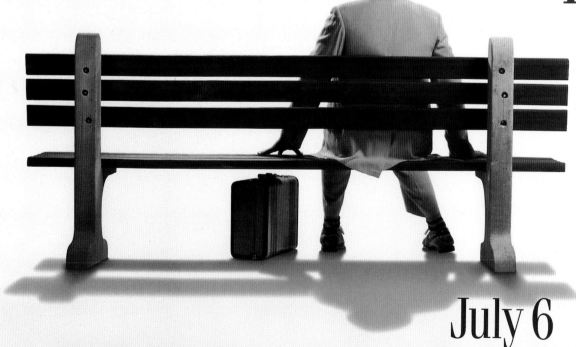

July 6

Paramount Pictures presents a Steve Tisch/Wendy Finerman production a Robert Zemeckis film Tom Hanks Forrest Gump Robin Wright Gary Sinise
Mykelti Williamson and Sally Field co-producer Charles Newirth music by Alan Silvestri executive music producer Joel Sill edited by Arthur Schmidt production designer Rick Carter director of photography Don Burgess based on the novel by Winston Groom screenplay by Eric Roth

READ THE PAPERBACK
FROM POCKET BOOKS

SPECIAL VISUAL EFFECTS BY
INDUSTRIAL LIGHT & MAGIC

produced by Wendy Finerman Steve Tisch Steve Starkey directed by Robert Zemeckis

SOUNDTRACK AVAILABLE ON EPIC SOUNDTRAX

Swingers (1996)
US 41 × 27 in. (104 × 69 cm)
Photo by Matthew Ralston

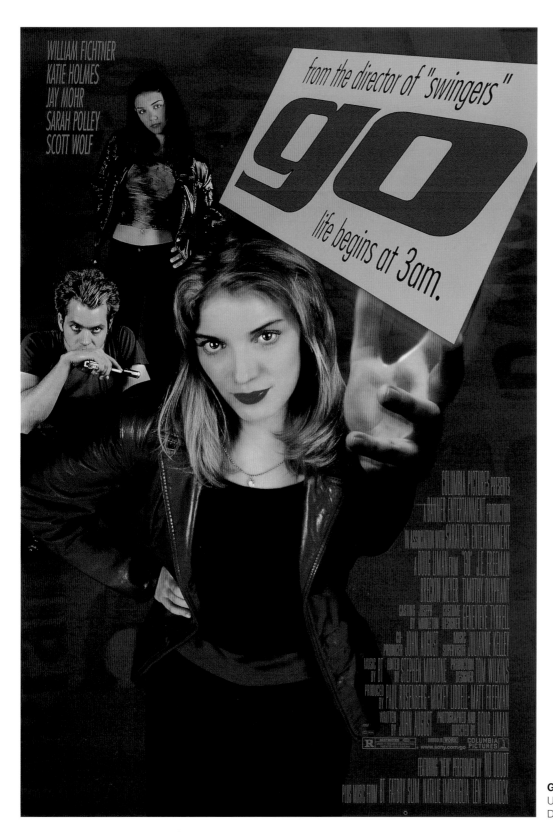

Go (1999)
US 41 × 27 in. (104 × 69 cm)
Design by Giuseppe Lipari & Evelyn Vaisman

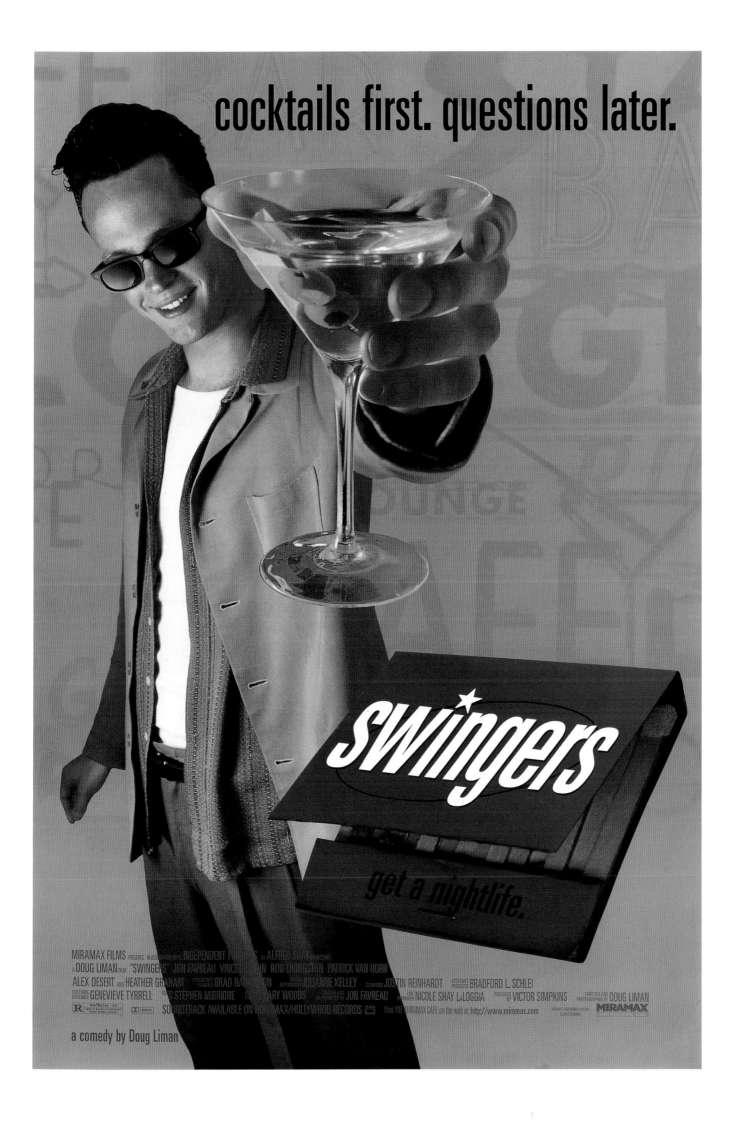

Austin Powers:
International Man Of Mystery (1997)
US 41 × 27 in. (104 × 69 cm)
(Advance)
Photo by Blake Little

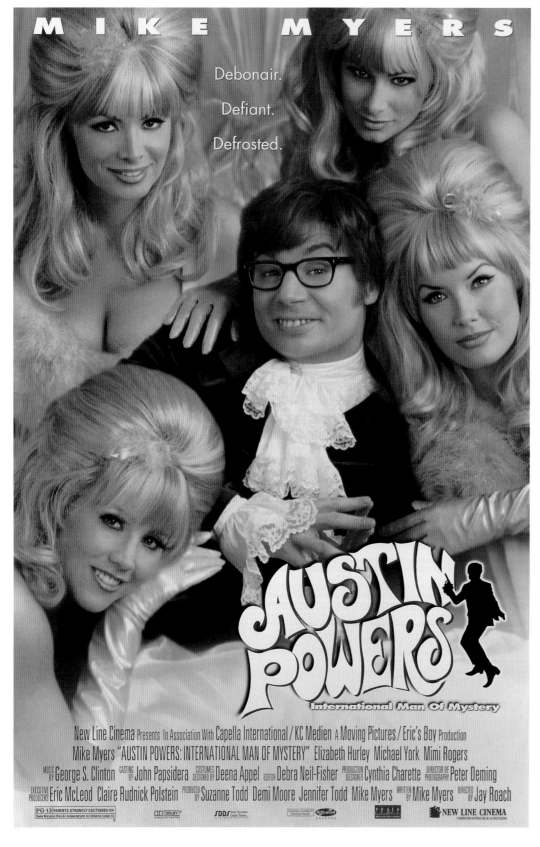

Austin Powers:
International Man Of Mystery (1997)
US 41 × 27 in. (104 × 69 cm)
Photo by Blake Little

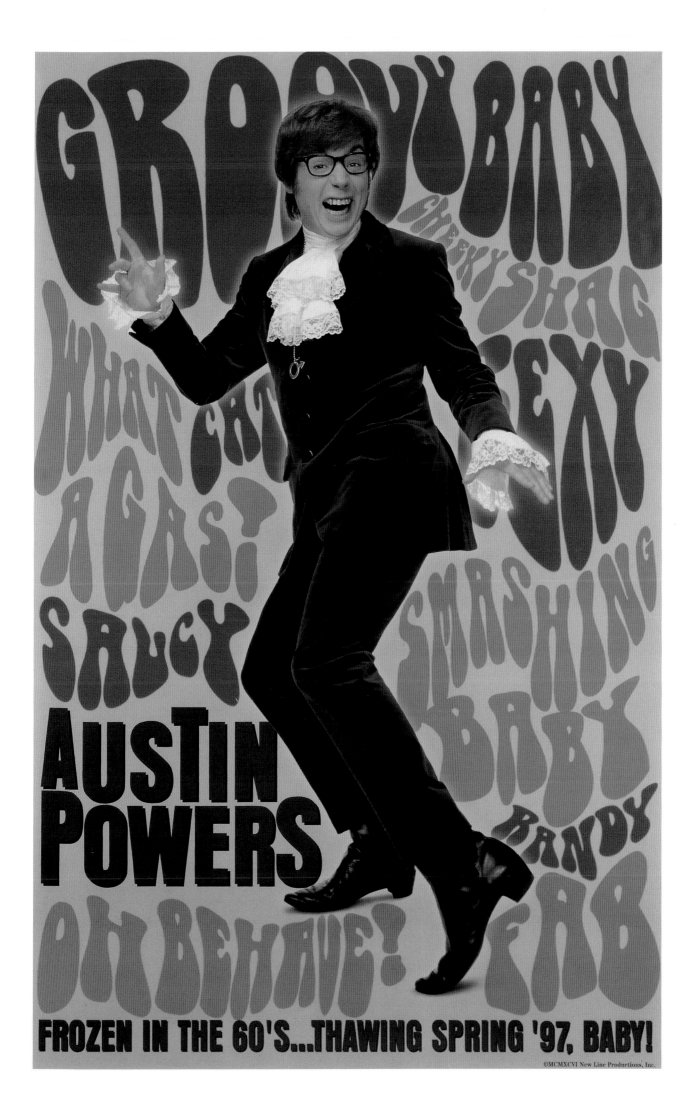

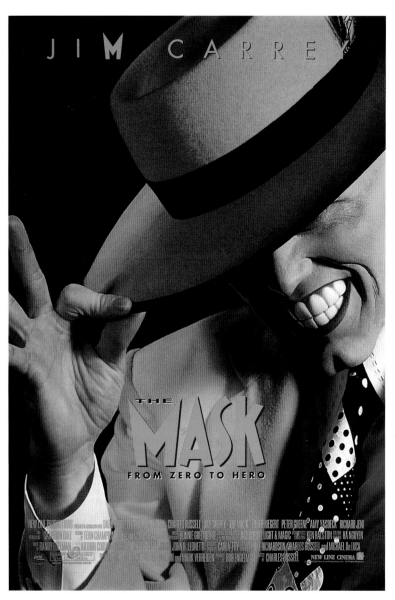

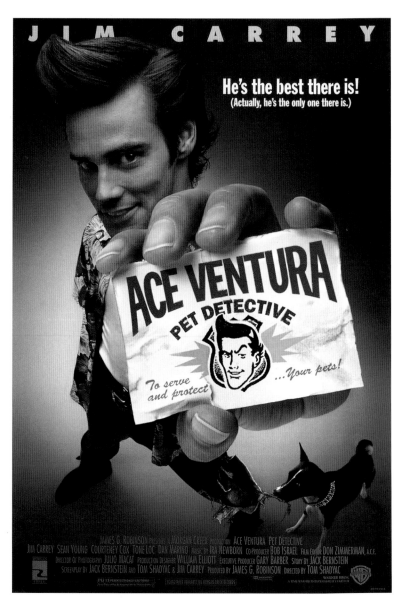

The Mask (1994)
US 41 × 27 in. (104 × 69 cm)
Photo by Darren Michaels
Design by Steve Klippenstein

Ace Ventura: Pet Detective (1994)
US 41 × 27 in. (104 × 69 cm)
Photo by Jon Farmer
Design by Evan Wright, Jen MaHarry
& Lucinda Cowell

The Truman Show (1998)
US 41 × 27 in. (104 × 69 cm)
(Advance)
Photo by David La Chapelle
& Melinda Sue Gordon
Design by Rob Silvers

JIM CARREY

the TRUMAN show
THE STORY OF A LIFETIME

PG PARENTAL GUIDANCE SUGGESTED
SOME MATERIAL MAY NOT BE SUITABLE FOR CHILDREN

www.truman-show.com

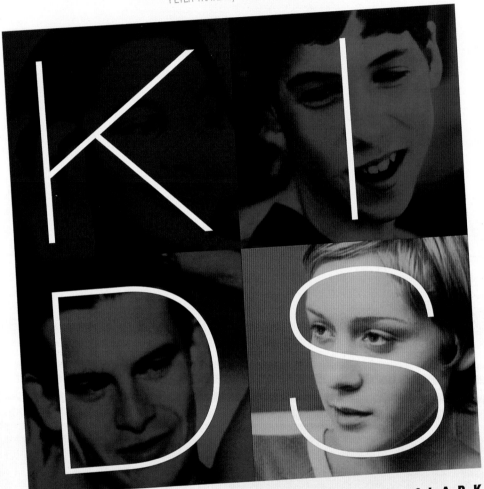

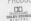

Kids (1995)
US 41 × 27 in. (104 × 69 cm)
Photo by Larry Clark
Creative direction by Robert Rainey

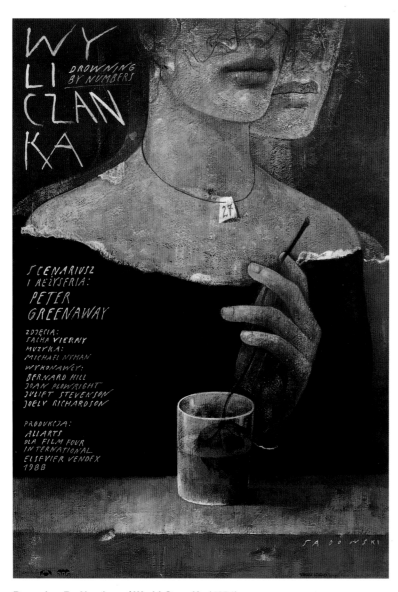

Drowning By Numbers / Wy Li Czan Ka (1991)
Polish 38 × 27 in. (97 × 69 cm)
Art by Wiktor Sadowski

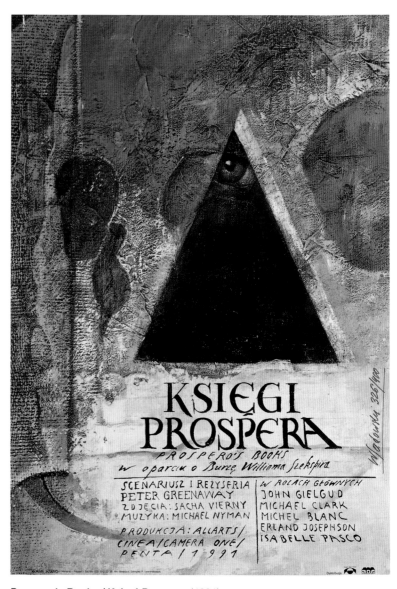

Prospero's Books / Ksiegi Prospera (1991)
Polish 38 × 27 in. (97 × 69 cm)
(Signed and numbered by artist – 326/400)
Art by Wiktor Sadowski

The Pillow Book (1996)
Polish 38 × 26 in. (97 × 69 cm)
Art by Wiktor Sadowski

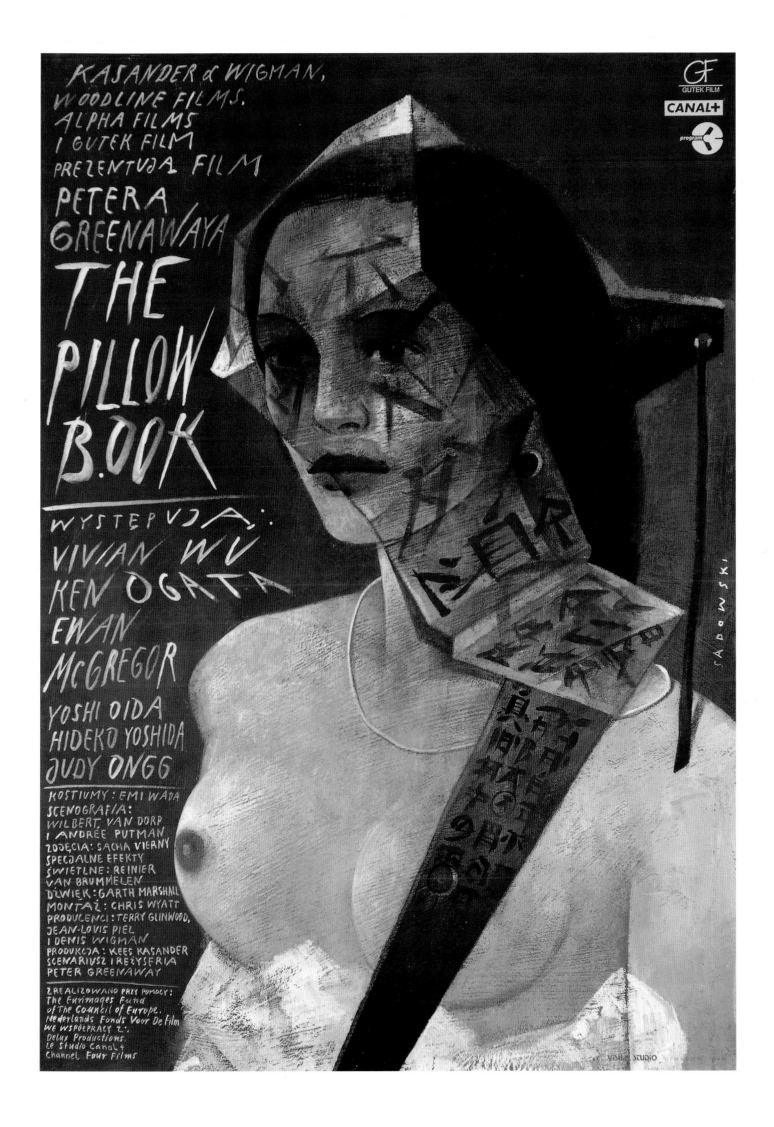

Dick Tracy (1990)
US 41 × 27 in. (104 × 69 cm)
(Advance – Madonna (Withdrawn))
Art by Johnny Kwan

Dick Tracy (1990)
US 41 × 27 in. (104 × 69 cm)
(Advance – Tracy)
Art by Johhny Kwan

The Two Jakes (1990)
US 41 × 27 in. (104 × 69 cm)
Art by Robert Rodriguez

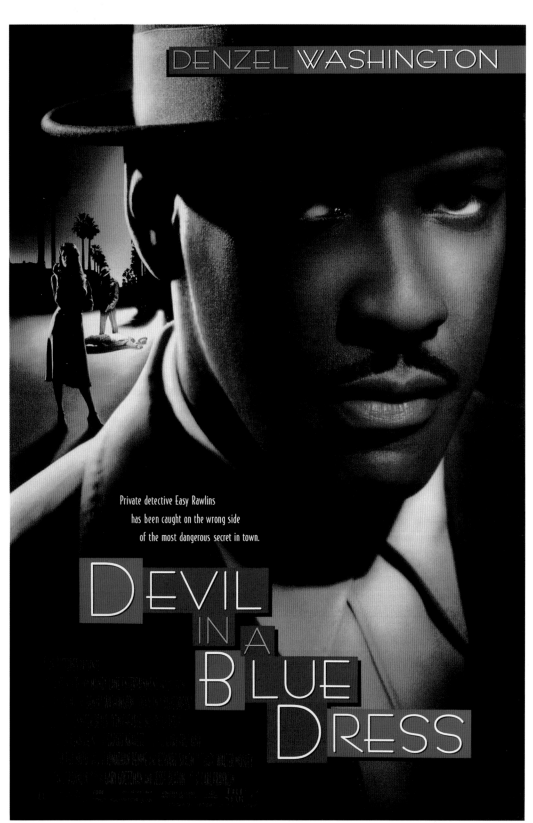

Devil In A Blue Dress (1995)
US 41 × 27 in. (104 × 69 cm)
Photo by Firooz Zahedi
Design by Randi Braun, Werndorf & Associates

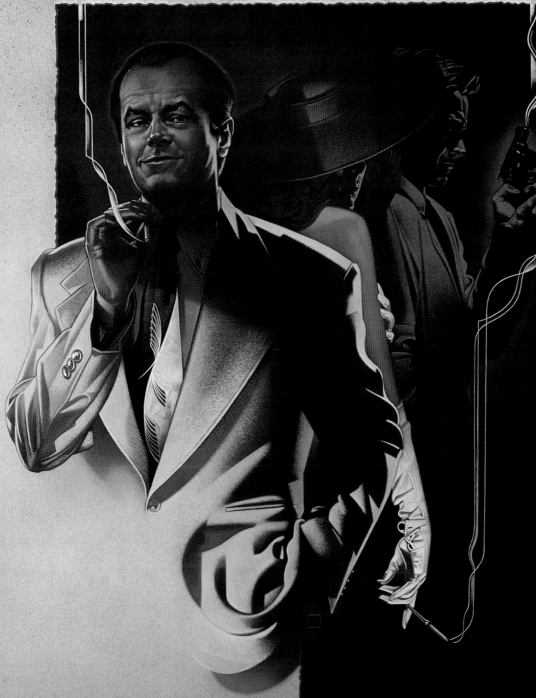

Jackie Brown (1997)
US 41 × 27 in. (104 × 69 cm)
(Advance – Pam Grier)
Photo by George Lange
Creative direction by
Tod Tarhan & Robert Rainey

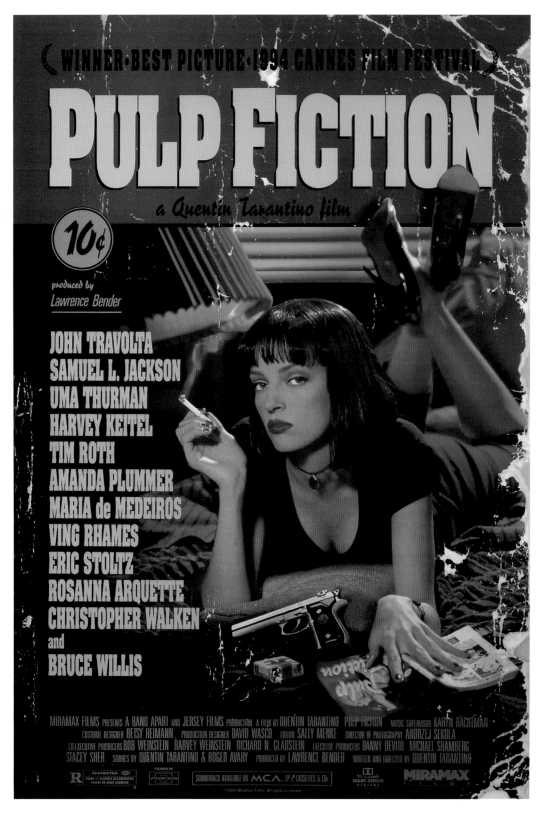

Pulp Fiction (1994)
US 41 × 27 in. (104 × 69 cm)
Photo by Firooz Zahedi

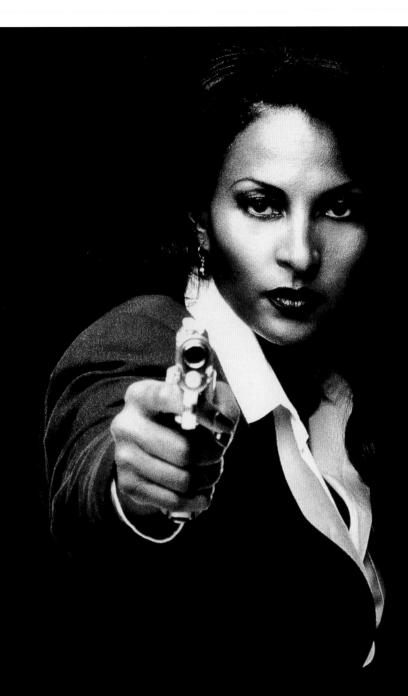

PAM GRIER

is

Jackie Brown

a Quentin Tarantino film

CHRISTMAS DAY

MIRAMAX

Reservoir Dogs (1992)
US 40 × 27 in. (102 × 69 cm)
Art direction and design by John Sabel

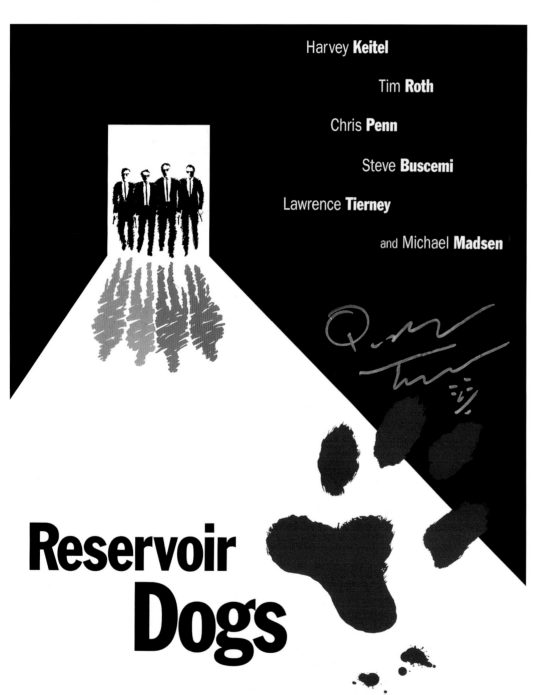

Reservoir Dogs (1992)
US 40 × 27 in. (102 × 69 cm)
(Cannes Film Festival – Signed by Quentin Tarantino)

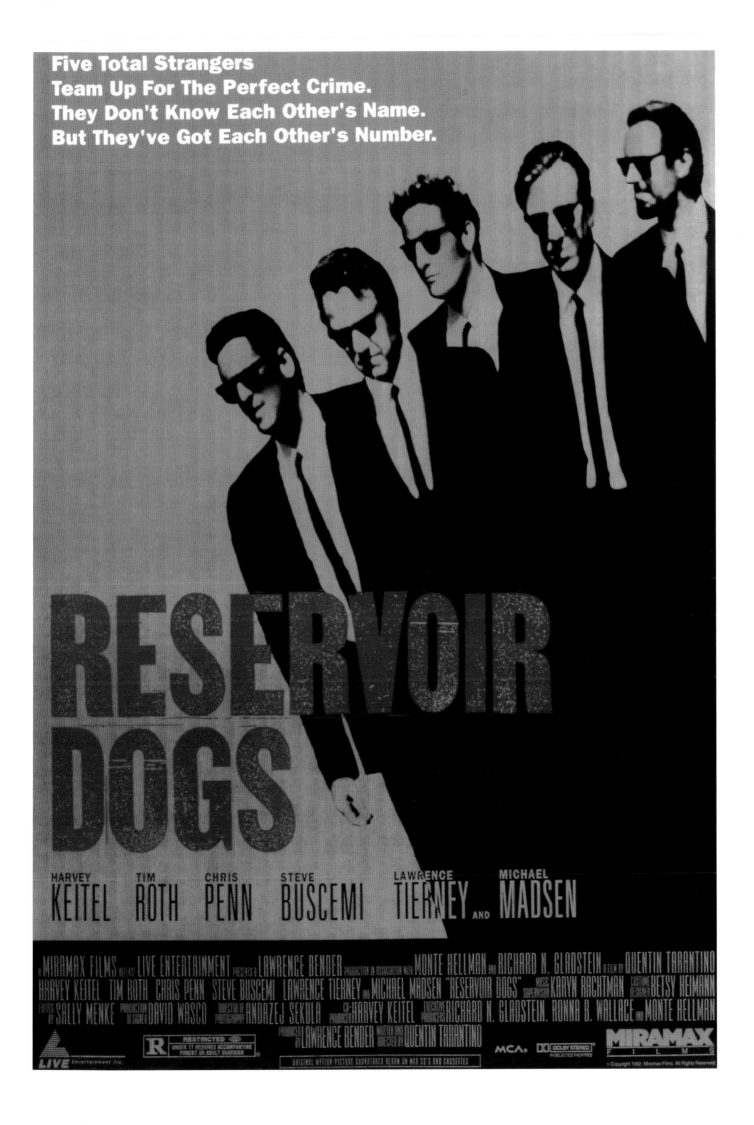

Trainspotting 18

THIS FILM IS EXPECTED TO ARRIVE...

23:02:96

From the team that brought you Shallow Grave

#1 RENTON

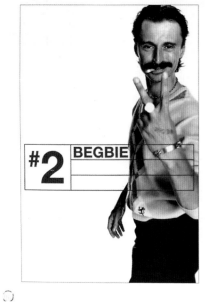

#2 BEGBIE

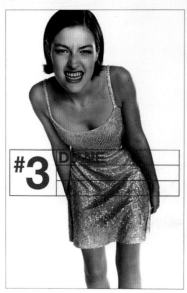

#3 DIANE

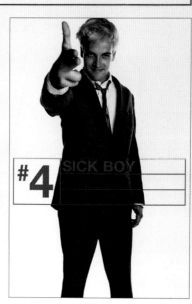

#4 SICK BOY

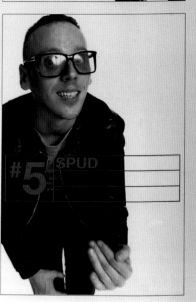

#5 SPUD

Trainspotting (1996)
British 30 × 40 in. (76 × 102 cm)
(Advance)
Photo by Lorenzo Agius

Lock, Stock And Two Smoking Barrels (1998)
US 41 × 27 in. (104 × 69 cm)
Design by Greg Higgins

Goodfellas (1990)
US 41 × 27 in. (104 × 69 cm)
Photo by Dirck Halstead
Design by Rick Lynch

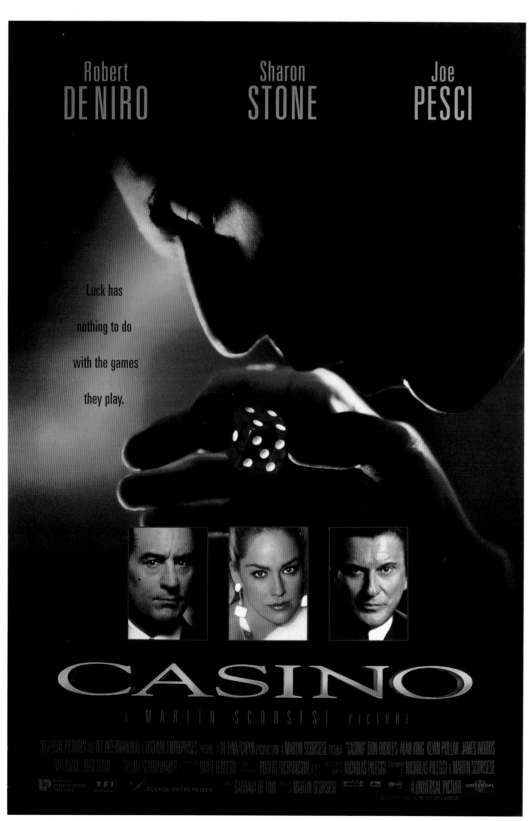

Casino (1995)
US 41 × 27 in. (104 × 69 cm)
(International)
Photo by Phillip Caruso
Design by Melanie Pitts Green

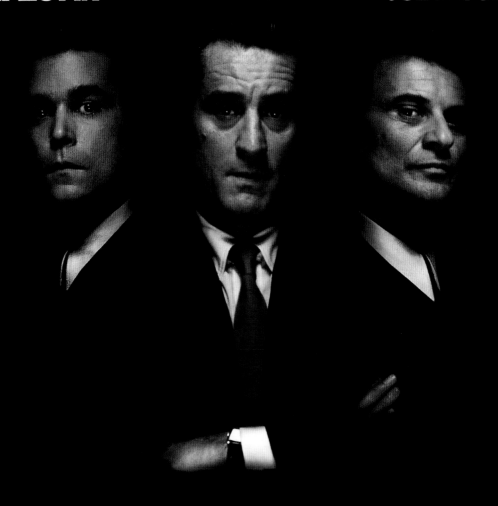

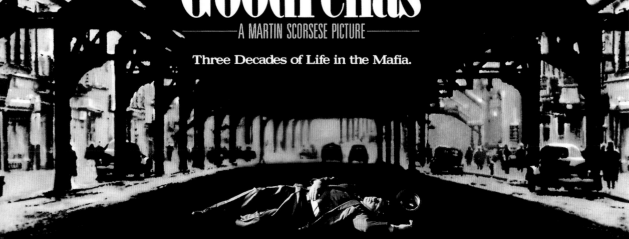

Mission: Impossible (1996)
US 41 × 27 in. (104 × 69 cm)
(Advance)
Photo by Murray Close

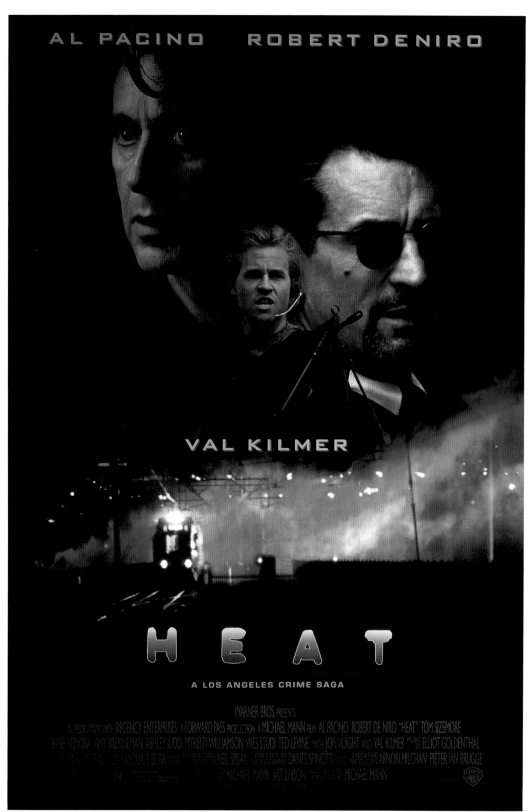

Heat (1995)
US 41 × 27 in. (104 × 69 cm)
Design by Stephan Lapp
Creative direction by Tony Seiniger

TOM CRUISE

MISSION: IMPOSSIBLE

MAY 22

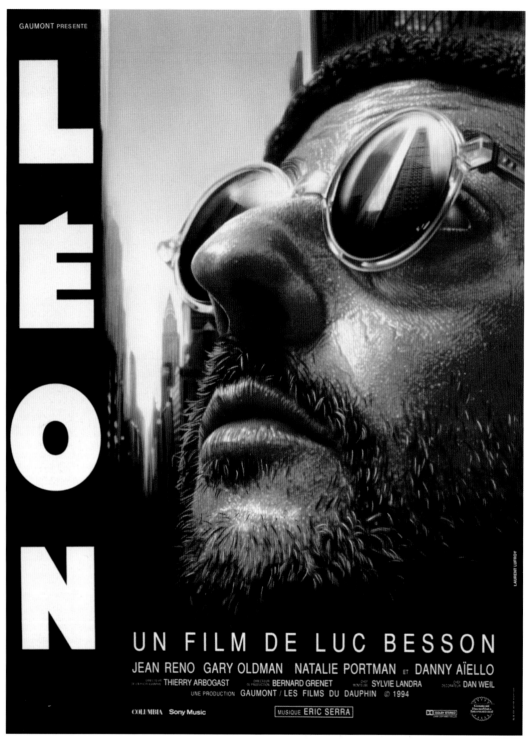

Leon (1994)
French 21 × 15 in. (53 × 38 cm)
Art by Laurant Lufroy

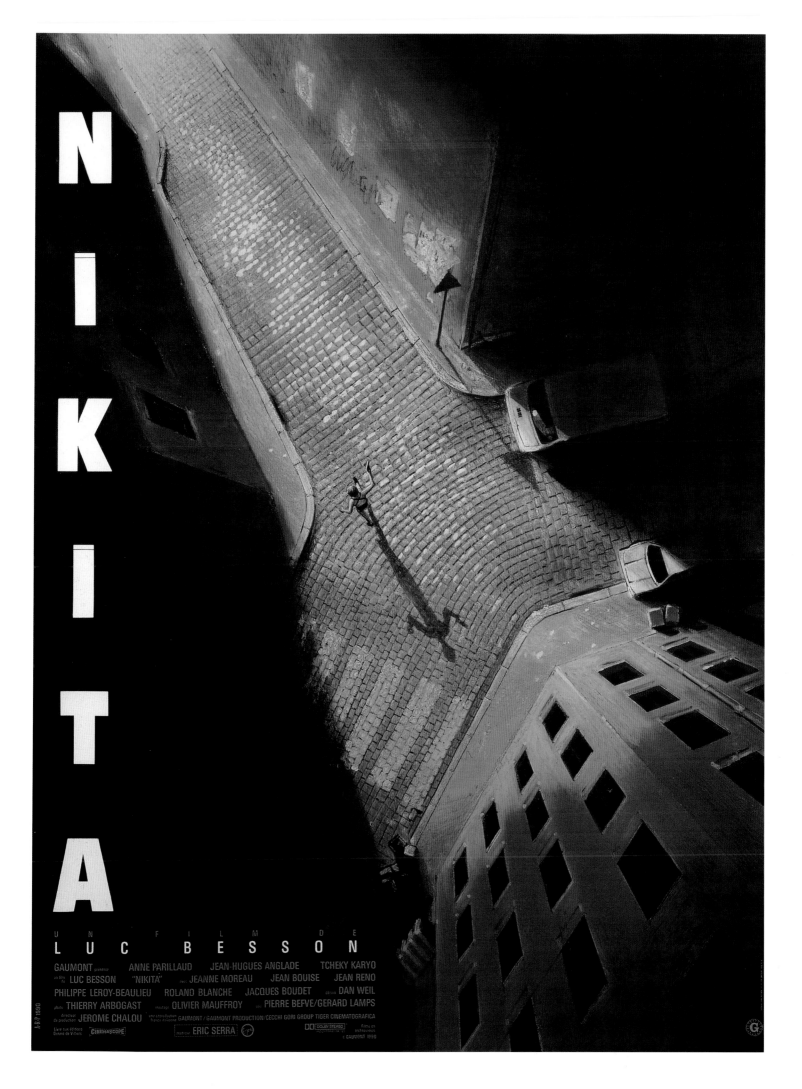

Carlito's Way (1993)
US 41 × 27 in. (104 × 69 cm)
Photo by Louis Goldman
Design by Georgia Young

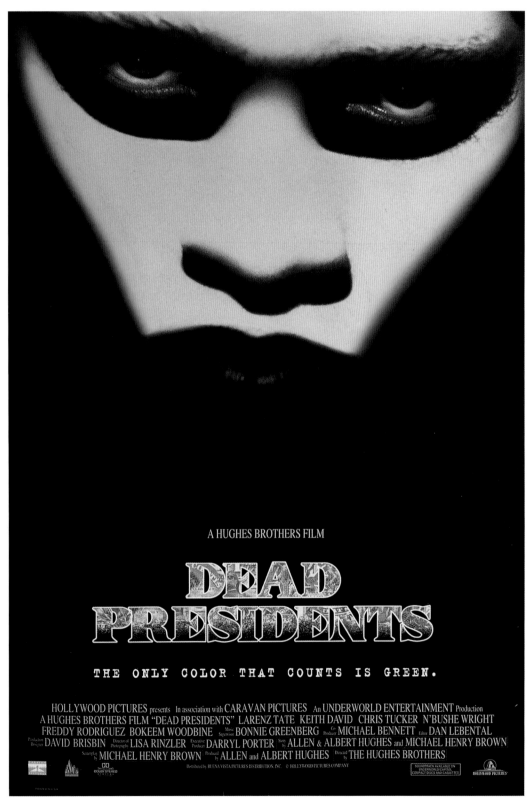

Dead Presidents (1995)
US 41 × 27 in. (104 × 69 cm)
(Advance)
Photo by Melodie McDaniel
Design by Randi Braun

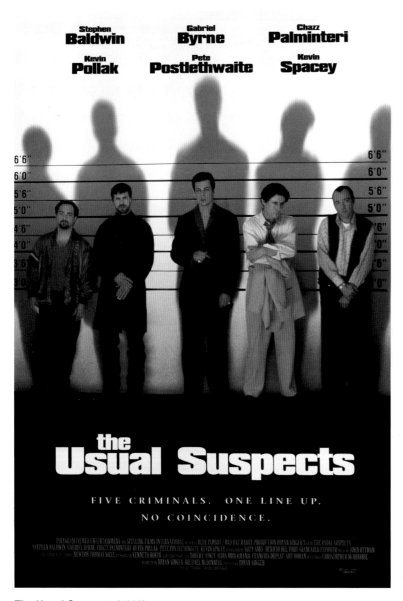

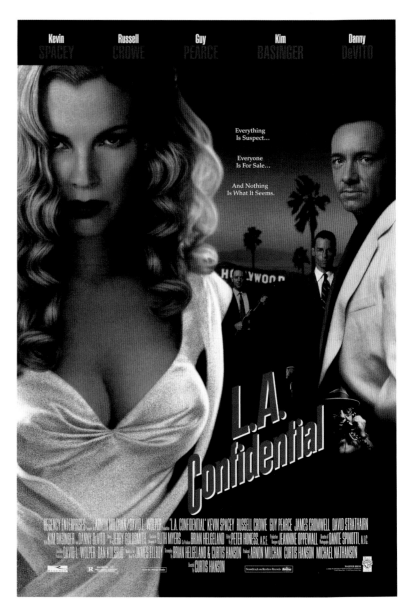

The Usual Suspects (1995)
British 40 × 27 in. (102 × 69 cm)
Photo by Linda R. Chen

L.A. Confidential (1997)
US 40 × 27 in. (102 × 69 cm)

Albino Alligator (1996)
US 41 × 27 in. (104 × 69 cm)
Art by Nicholas Gretano

MATT
DILLON

FAYE
DUNAWAY

GARY
SINISE

ALBINO
ALLIGATOR

Deliberate sacrifice
for deliberate gain.

A NEW THRILLER DIRECTED BY KEVIN SPACEY

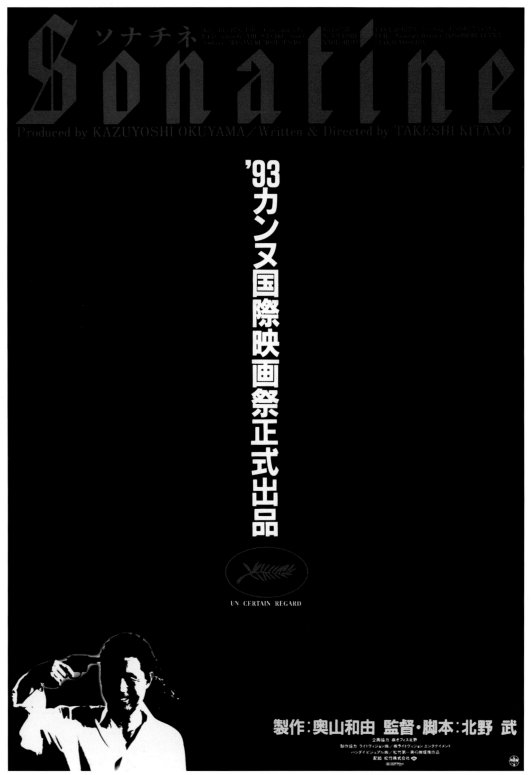

Sonatine (1993)
Japanese 30 × 20 in. (76 × 51 cm)

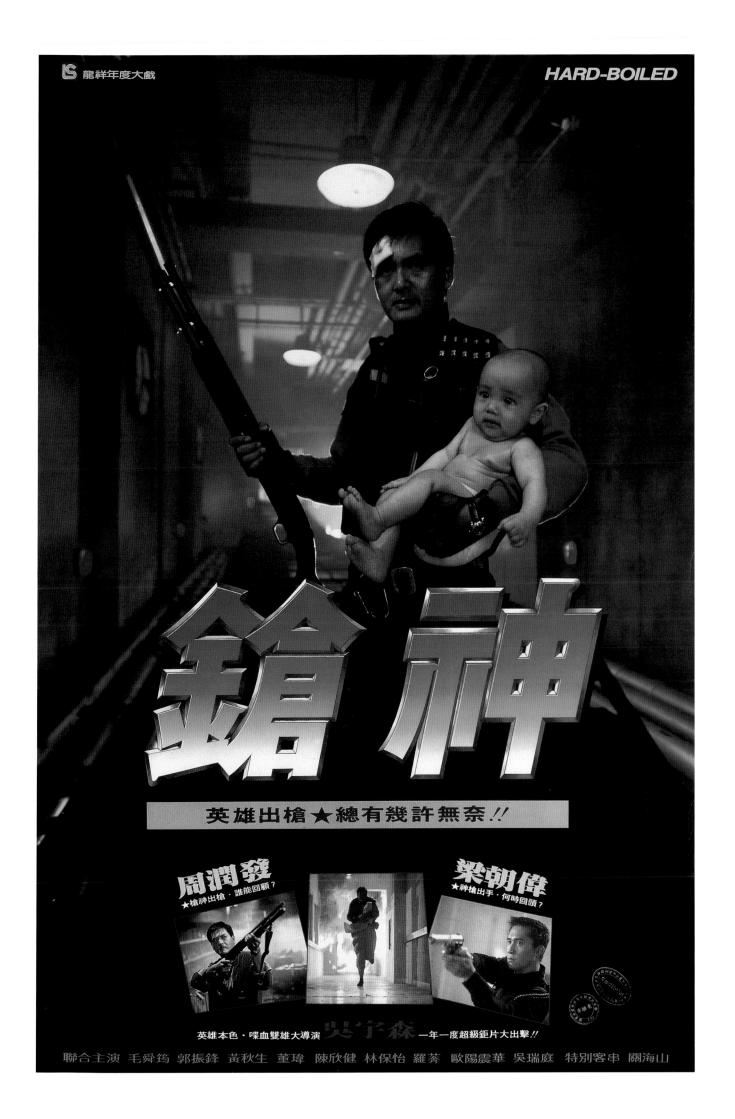

Chong Qing Sen Lin (Chungking Express) (1994)
Hong Kong 26 × 37 in. (66 × 94 cm)

A Fei Jing Juen (Days Of Being Wild) (1991)
Hong Kong 26 × 37 in. (66 × 94 cm)

Duo Luo Tian Shi (Fallen Angels) (1998)
German 33 × 23 in. (84 × 58 cm)

Fünf exzentrische
Fallen Angels in einem
atemberaubenden Puzzle-Spiel
voller Sex und Gewalt.

Kinowelt Filmverleih
präsentiert
eine JET TONE PRODUCTION
einen Film von Wong Kar-wai
FALLEN ANGELS
Leon Lai Ming
Takeshi Kaneshiro
Charlie Young
Michele Reis
Karen Mok
Schnitt William Chang
und Wong Ming Lam
Kamera Christopher Doyle
Ausstattung William Chang
Stunt-Coordination Poon Kin-kwun
Musik Frankie Chan
und Roel A. Garcia
Co-Produzent Jacky Pang Yee-wah
Ausführender Produzent Wong Kar-wai
Produzent Jeff Lau
Drehbuch und Regie Wong Kar-wai
im Verleih der Kinowelt

FALLEN
ANGELS

Nach Chungking Express
der neue Film von Wong Kar-wai

http://www.kinowelt.de

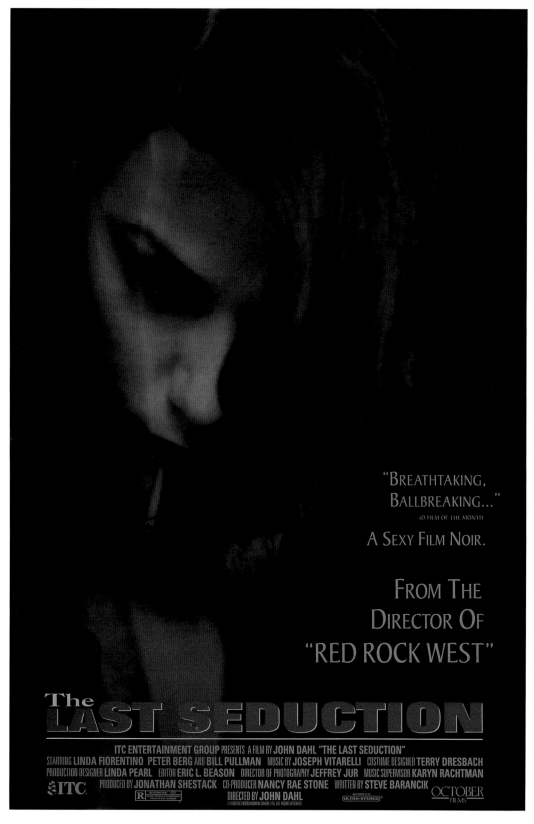

The Last Seduction (1994)
US 41 × 27 in. (104 × 69 cm)
Design by John Soltis

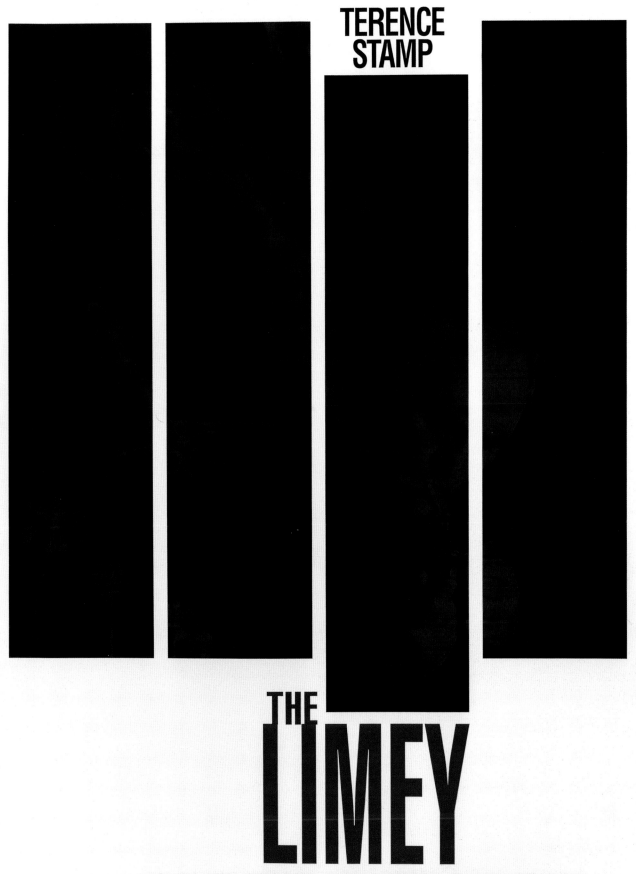

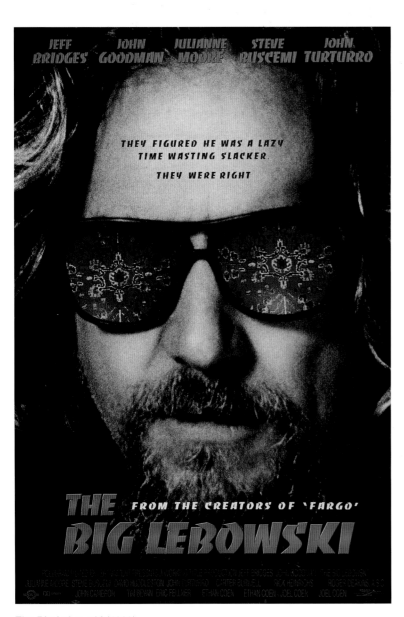

The Big Lebowski (1998)
US 41 × 27 in. (104 × 69 cm)
(International)

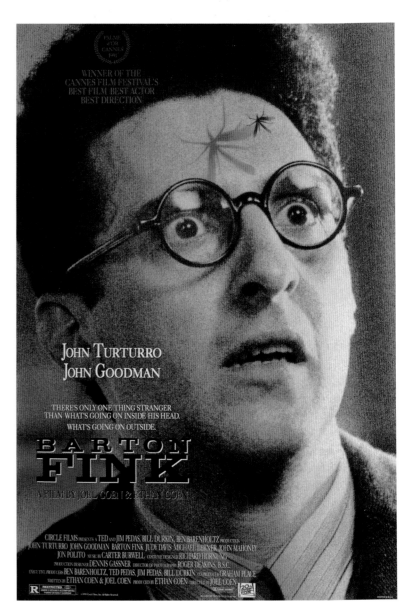

Barton Fink (1991)
US 41 × 27 in. (104 × 69 cm)
Photo by Melinda Sue Gordon
Design by Evan Wright & Tony Sella

Fargo (1996)
US 41 × 27 in. (104 × 69 cm)
Art direction and design by K. Swann,
E. Kintler & J. Waxel

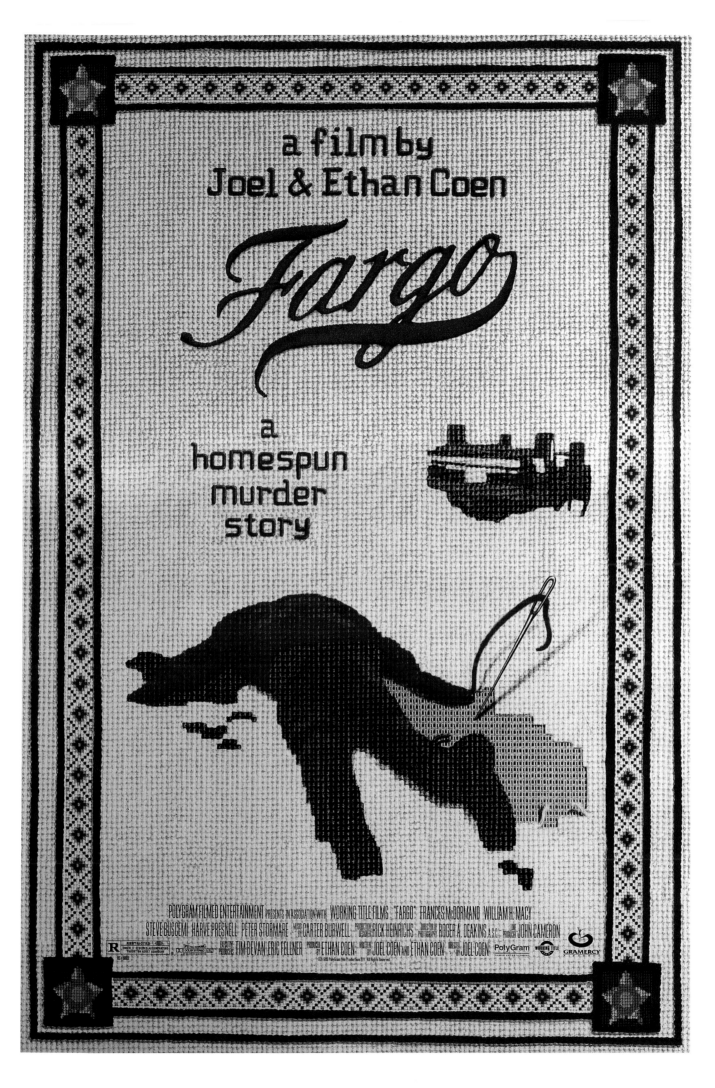

Unforgiven (1992)
US 41 × 27 in. (104 × 69 cm)
(First Advance)
Photo by Eddie Adams
Design by Bill Gold

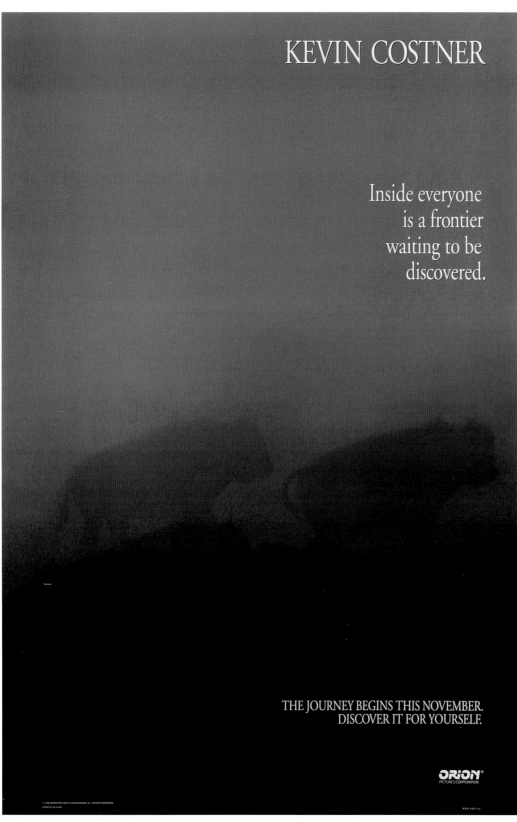

Dances With Wolves (1990)
US 41 × 27 in. (104 × 69 cm)
(Advance)
Art direction by Tom Brothers

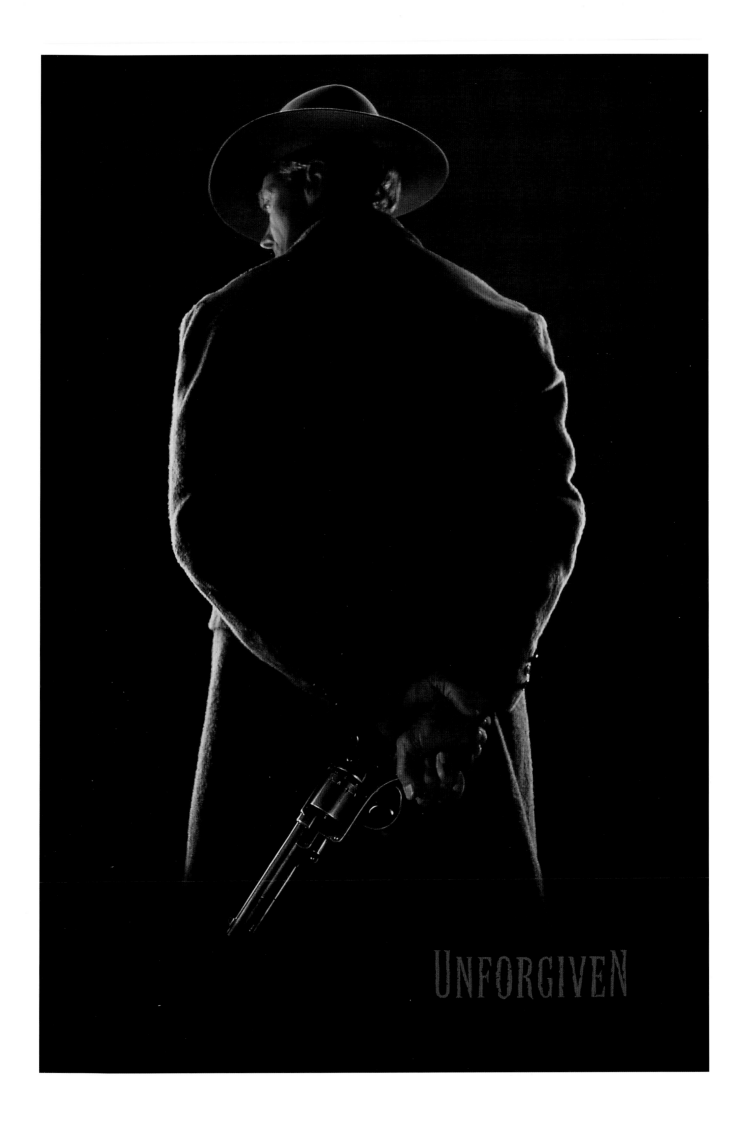

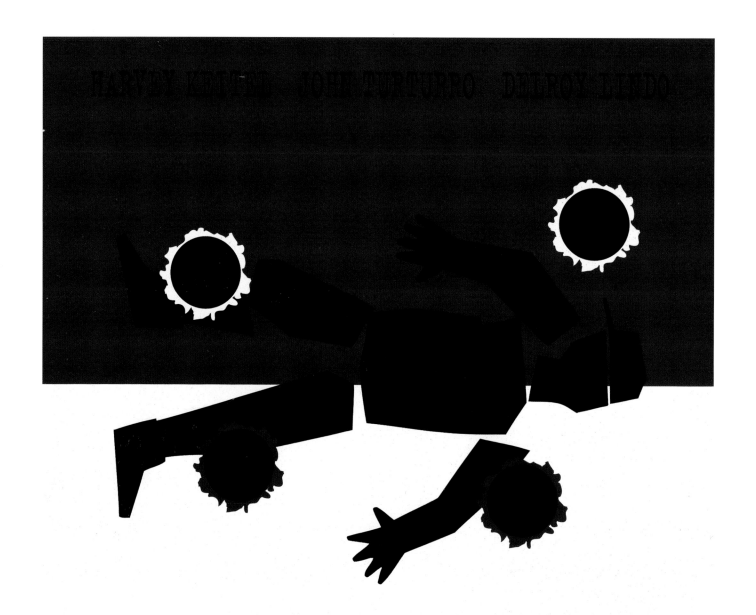

A SPIKE LEE JOINT

CLOCKERS

UNIVERSAL PICTURES PRESENTS A 40 ACRES AND A MULE FILMWORKS PRODUCTION A SPIKE LEE JOINT "CLOCKERS"

MEKHI PHIFER · ISAIAH WASHINGTON · KEITH DAVID · PEE WEE LOVE CASTING BY ROBI REED-HUMES C.S.A.

PRODUCTION DESIGNER ANDREW McALPINE ORIGINAL MUSIC TERENCE BLANCHARD EDITOR SAM POLLARD DIRECTOR OF PHOTOGRAPHY MALIK HASSAN SAYEED

CO-PRODUCER RICHARD PRICE EXECUTIVE PRODUCERS ROSALIE SWEDLIN · MONTY ROSS BASED ON THE BOOK BY RICHARD PRICE

SCREENPLAY BY RICHARD PRICE AND SPIKE LEE PRODUCED BY MARTIN SCORSESE · SPIKE LEE · JON KILIK DIRECTED BY SPIKE LEE

 A UNIVERSAL RELEASE

index of film titles

Clockers (1995)
US 41 × 27 in. (104 × 69 cm)
(Withdrawn)

Back Cover:
Reservoir Dogs (1992)
British 30 × 40 in. (76 × 102 cm)